THE LIFE
OF
TINTORETTO

CARLO RIDOLFI

THE LIFE
OF
TINTORETTO

and of his children Domenico and Marietta

translated and with an introduction by

CATHERINE ENGGASS
and
ROBERT ENGGASS

THE PENNSYLVANIA STATE UNIVERSITY PRESS
UNIVERSITY PARK AND LONDON

Library of Congress Cataloging in Publication Data

Ridolfi, Carlo, 1594–1658.
The life of Tintoretto, and of his children
Domenico and Marietta.

Translated from vol. 2 of: Maraviglie dell'arte, ovvero,
Le vite degli illustri pittori veneti e dello Stato.
Includes bibliographical references and index.
1. Tintoretto, 1512–1594. 2. Painters—Italy—
Biography. 3. Children—Italy—Biography. I. Title.
ND623.T6R513 1984 759.5 [B] 83-23829
ISBN 0-271-00369-3

CONTENTS

ACKNOWLEDGMENTS

Thanks are due first and foremost to the University of Georgia and especially to Dr. Virginia Trotter, Vice President for Academic Affairs, who has done so much to support and encourage a vigorous program of research and publication in art history at the University. We would also like to thank the staff of the Kunsthistorisches Institut in Florence, and particularly the Director, Dr. Gerhard Ewald; the Assistant, Dr. Michael Sempf; the Editor of the Siena Project, Dr. Monika Butzek, and the Librarian, Dr. Margaret Davis, each one of whom made every effort to assist us and to make our stay pleasant during the summer of the 'soleone.' We are also most grateful to the Director of the Biblioteca Correr in Venice, Dr. Attilia Dorigato, and her able staff, who were unfailingly helpful. And finally, we owe a special debt of gratitude to our colleague Professor James Anderson, who translated the Latin inscriptions.

INTRODUCTION

I

idolfi's biography is far and away the most important single primary source of information on Tintoretto. In it are most of his paintings and almost everything we know about his life. Any up-to-date catalogue raisonné of Tintoretto's work must of necessity cite Ridolfi, not dozens but hundreds of times.

Ridolfi published his *Life of Tintoretto* separately in 1642 and included it, with occasional and very minor changes, in his large two-volume *Lives of the Venetian Painters* which appeared six years later.

The section of Ridolfi's *Tintoretto* that has probably made the strongest impression on modern critics is that which deals with the painter's working methods. The motto that, according to what Ridolfi tells us, Tintoretto hung in his studio—"Michelangelo's design and Titian's color"—was even then not a new saying, but it does express succinctly the two greatest outside influences on Tintoretto's art. That Tintoretto, a

Venetian, drew heavily on Titian goes without saying. But
without the information that Ridolfi gives us it would be hard
to account for the all-pervading influence of Michelangelo, as
well as the sources of so many of Tintoretto's highly original
compositional devices: the bizarre lighting effects, the dra-
matic foreshortenings, and the theatrical settings.

Ridolfi tells us that, along with the plaster casts of antique
sculptures that he acquired at considerable expense, Tin-
toretto also kept in his studio small-scale copies, made by
Daniele da Volterra, of Michelangelo's *Night, Day, Dawn,*
and *Dusk* from the Medici tombs. These figures he drew over
and over again from various angles, always emphasizing solid
modeling and the accurate foreshortening of form. Like
others in this period he also drew from living models and on
occasion made anatomical studies from corpses. Much more
unusual was his use of miniature architectural models which
could be viewed from any angle. These he peopled with small
doll-like figures of wax or clay which he clothed in appropri-
ate costumes. By placing miniature lamps against the win-
dows he was able to produce dramatic light effects which
could then be reproduced in his paintings. Some of his wax
models he hung by strings from the ceiling so that he could
draw or paint them as they appeared when seen sharply from
below.

We cannot look to Ridolfi for sophisticated stylistic analy-
sis, but he has been justly complimented for the accuracy and
precision of his descriptions of individual paintings. This is
especially helpful for the proper identification of works that
have been lost or exist in several versions and are of uncer-
tain provenance. Equally valuable, especially in the case of
canvases in private collections, is Ridolfi's ability to identify
accurately the unusual or recondite themes of the paintings
he discusses. Though except for his training as a painter he
seems to have had little formal education, he was by the
standards of the day very much an educated man. The ample
quotations with which he ornamented his writings show him
to be on familiar terms with a very large number of ancient
Latin writers and with most of the Italian poets. Some of
Ridolfi's finest descriptions are of the paintings by Tintoretto

in the School of San Rocco. He brings to them the enthusiasm and excitement that he himself felt as a professional painter for the work of an artistic genius who brought himself and Venice honor and fame.

From Ridolfi too comes our image of Tintoretto as an artist obsessed with the act of painting, always eager to overwhelm his competitors with the number and size of his pictures, always anxious to capture from them the most important public commissions, at whatever cost. From what Ridolfi tells us—and we have little reason to doubt him—Tintoretto was almost totally oblivious to money, but was very much dazzled by fame.

Ridolfi's first love is what we now call the Golden Age of Venetian Painting, the sixteenth century. Of the painting of his own day, the new Baroque art that brought about a revival of painting in seventeenth-century Venice, he understood little and liked less. Over and over again Ridolfi tells us that Tintoretto strove to reach beyond nature, to improve upon it. Nowhere does he refer to the artistic theories of his own day. These, as formulated by Giulio Mancini and others, were based first and foremost on a posteriori knowledge, on the direct observation of nature, the selection of parts taken from nature, and the combining of those parts.[1] While Ridolfi never completely rejects nature as a source, he seems to draw his artistic theory from those writers who were inspired by the art of Mannerism, above all from Gian Paolo Lomazzo.[2] Lomazzo urged the artist not to rely exclusively on nature, but rather to seek out the purified images that exist in the mind of God which could be glimpsed, though at a distance, by the artist who was divinely inspired. The artist thus becomes privy to a priori knowledge.

II

Though Ridolfi is remembered today almost entirely for his biographies of Venetian artists, he was not a writer by profession. In his own day he was known as a painter, and as such he enjoyed a certain modest success. Most of what we know

about his life comes from his autobiography,[3] supplemented by the documents published early in this century by Vitaliani.[4]

Ridolfi was born on 1 April 1594 in Lonigo, a small town near Vicenza on the Venetian mainland. His father's family came from Germany around the year 1500, during the wars in Lombardy. When Carlo was five years old his father, Marco, died.[5] Marco's widow, Angela Boschetto, married a certain Andrea Schiasiero of Lonigo, by whom she had nine children. Andrea encouraged the young boy to think seriously of art as a career, sending him first to study under an unnamed German painter in Lonigo, and then later, when he had made adequate progress, arranging for him to continue his studies in Venice. There the young Ridolfi, then about thirteen years old, joined the studio of Antonio Vassilacchi called Aliense, a late Mannerist follower of both Veronese and Tintoretto. He stayed with Aliense, he tells us, for five years, and then at the age of eighteen embarked on an extensive program of studies in the humanities. His *Lives of the Venetian Painters* is filled with quotations from famous writers. There are literally hundreds of references to ancient Latin authors, not only the most famous, such as Virgil, Ovid, Lucretius, and Catullus, but lesser figures as well. Among the Italian writers he favored Dante and Petrarch, but also Ariosto, Tasso, and the Mannerist poet Marino. In the field that we would now call architectural history he studied the writings of Palladio, Serlio, and Vignola.

After finishing his literary studies he returned to Lonigo where he found work as a painter. By the time he was in his late twenties he was beginning to get important public commissions. But in 1629 he hurried back to Venice to be with his old master, Aliense, during his last illness. "While he was alive," Ridolfi wrote, "I honored him as a father, I loved him as a friend, and after he was dead I mourned him as if I had lost a part of my own being."[6]

The following year Venice was struck by a plague so devastating that it carried off a substantial part of the population. Ridolfi fled to Lonedo, a small town on the mainland, where

he celebrated, with the customary phrases, the virtues of simple rustic living. In 1631, as soon as he got word that the plague had ceased, he hurried back to Venice. There his career flourished. In 1642 or shortly thereafter, the Venetian Senate honored him with the gift of a gold chain and inducted him into the Order of St. Mark, thus making him a knight. In 1645 he was awarded a second knighthood, this time from Innocent X, the Odescalchi pope.

Late in life, when he was sixty-one years old, Ridolfi married. His bride, Pasquetta Vidali, was apparently a person with whom he had been living for some time. Three years later he was dead. He came down with a fever on 17 August 1658 and died 5 September. He was buried with suitable obsequies in the cloister of Santo Stefano, in the city he loved. Of Venice he wrote "O fortunate nation, founded on firm land amidst the moving waters, magnificent in the grandeur of its temples and its palaces, abundantly provided with riches and material goods, notable for its flourishing nobility, admirable for its most sacred laws, glorious for its uninterrupted liberty, and beloved for the benevolence of its government."[7]

Ridolfi said that he had a "special instinct" for painting. It is a view that has gained little support. His all-consuming admiration for the art of the past prevented him from appreciating the fresh new ideas that were being developed by his contemporaries. At best he may be considered an epigone.

His earliest datable works are two large canvases for the church of SS. Fermo e Rustico in his home town, Lonigo, *Blessed Lorenzo Giustiniani in Glory* and *Triumph of St. George,* both painted when he was twenty-eight years old.[8] Pallucchini calls them "awkward and impoverished recollections of sixteenth century motifs taken from Titian and Veronese."[9] Ridolfi himself characterizes them as "errors of my youth."

The primitivism that marks these first public commissions disappears during his early maturity. A good example is the *Adoration of the Magi* in S. Giovanni Elemosinario in Venice, which is generally considered to be Ridolfi's finest work.[10] In it the richly clad figures are pleasantly if conven-

tionally arranged to form an undulant progression that moves across the foreground plane on a parallel to the surface in the manner of Veronese. Other works of this period combine the compositional principles of Veronese with echoes of Palma Giovane.

A whole group of works, mentioned by Ridolfi in his autobiography but later forgotten, have recently been rediscovered on several small islands of the Dalmatian coast in what is now Yugoslavia but then formed a part of the Venetian empire overseas.[11] In these remote outposts the retardataire and often primitive aspects of Ridolfi's art were probably if anything an advantage. The Mannerist devices that mark most of these paintings—elongation of the figures, crowding of the compositions, translation of depth into height—recall the art of a past age but also harmonize well with the Greco-Byzantine art that provided Dalmatia with an indigenous artistic tradition. The most successful of these Dalmatian canvases, the one with the most gracefully posed figures and the fewest traces of primitivism, is the *Madonna of the Rosary* in the parish church of Nerezisce on the island of Brač.[12]

In Ridolfi's final years he often returned to the rigidly bisymmetrical compositions that marked his first efforts, but with fewer Mannerist characteristics. Typical of these late works is the *Miracle of Soriano,* originally in Treviso but now in the Accademia in Venice, which Ridolfi painted in 1656, two years before he died.[13]

He also assembled an important collection of drawings.[14] Three volumes inscribed by Ridolfi as having been put together between 1631 and 1638, are now in the Library of Christ Church College, Oxford. Since Ridolfi did not die until twenty years later it seems reasonable to suppose, as Murano has suggested, that the collection was once a good bit larger. The drawing collection of Christ Church College, which came to Oxford as a group, was assembled by John Guise, a general who had served under Marlborough in the Netherlands campaign of 1708. Ridolfi's three quarto volumes, which once formed part of the Guise Collection, contain securely attrib-

uted works by Pisanello, Leonardo da Vinci, and Michelangelo. It is also probable, as Parker has pointed out, that the splendid Tintoretto drawings now in Christ Church were once a part of the Ridolfi Collection.[15]

The suggestion has been made that Ridolfi, like many other painters in seventeenth-century Venice, was also an art dealer. Haskell points out that, in contrast to other earlier writers, he shows an interest not only in the paintings in churches and other public places but also those in private collections. "In contrast to Vasari," Haskell writes, "we can deduce that he provides detailed descriptions of paintings to attract the attention of foreign collectors. . . . Many paintings thus described were bought shortly after the publication of his book, thus giving us to understand that he had achieved his purpose."[16]

Ridolfi is remembered above all for his artists' lives. In his youth he wrote a short novel, *The Tale of Lady Isotta of Pisa*, which appeared in Venice in 1620, but this type of literary effort was not to be repeated.[17] Two decades were to pass before he appeared again in print. In 1642 he published his *Life of Tintoretto*, with a dedication to the Venetian Senate and the ruling doge, Francesco Erizzo.[18] In his introduction he said that if this work found favor he would then complete his artists' biographies. Find favor it did: he was awarded a knighthood. Six years later he brought to completion and published his monumental study of the painters of Venice and her territories, of which the *Life of Tintoretto* forms but a small part. It is characteristic of the atmosphere of a city long known for its foreigners, as von Schlosser has pointed out, that the book is dedicated to two Dutchmen, the brothers Reinst, the one a senator in Amsterdam and the other the Dutch ambassador in Paris, both avid collectors of Italian art.[19]

Ridolfi's *Lives*, or *Maraviglie* as the abbreviated title is called in Italian, is the first full-scale Venetian counterpart to Giorgio Vasari's *Lives of the Artists*, which, though it had appeared almost a century earlier, was largely what Ridolfi's book was answering. Though from time to time Vasari had

felt compelled to admire an individual work by one of the Venetian painters, he never really approved of their techniques or understood their objectives, nor did he believe that the Venetian artists as a group were even remotely as important as the artists of his native Tuscany. Ridolfi's book is above all an attempt to make amends for the deficiencies of Vasari by pointing out the glories—the "Maraviglie"—of Venetian art and to affirm its supremacy over the art of any other school. Of necessity it is regional rather than peninsular in scope.

We do not know when Ridolfi began work on his *Maraviglie* but it is quite possible, as Puppi has suggested, that the book grew out of notes that he made for his drawing collection and then developed with the encouragement of various noblemen and members of the Venetian government. For these men the glorification of Venetian art, especially the art of the sixteenth century, Venice's Golden Age, was a form of glorification of the Venetian State.

Ridolfi protested that he was in no sense a professional writer. He had begun his *Lives* simply for his own amusement and to entertain his friends. He complains, like art historians of a later age, that he never imagined it would turn out to be such a long and tedious process.[20] In the end, however, it was his writing, not his painting, that brought him fame. Filippo Baldinucci, who wrote in the latter part of the seventeenth century, called it a wonderful work and indicated that he had drawn on it extensively in his own *Lives of the Artists* "to make," in his words, "my own biographies more complete and richer."[21]

Critics today prize Ridolfi for the breadth of his coverage and the accuracy of his descriptions. He is not especially perceptive of stylistic developments but he is, on the other hand, an acute observer of the vicissitudes of life and their effects on the emotions. He was also far ahead of his time on the issue of women's rights. His introduction to the brief biography of Tintoretto's daughter Marietta, which is included in this book, contains a vigorous defense of capable and talented women, and also an attack on the restrictions

placed on women that is so modern that it could well have been written in this century.

Luigi Lanzi, writing almost two hundred years ago, sums up Ridolfi's contribution as follows: "He is precise, vigorous, and he makes an effort to provide the reader with much information in few strokes of the pen—though he quotes rather too liberally from the poets. His best paintings are correct, his complaints against Vasari moderate, his description of paintings extremely precise, and they are obviously made by a person who is familiar with both history and mythology."[22] It is a judgement that stands up well.

<div align="right">

CATHERINE ENGGASS

ROBERT ENGGASS

</div>

NOTES

1. Giulio Mancini, *Considerazioni sulla pittura,* edited and annotated by A. Marucchi and L. Salerno, 2 vols., Rome, 1956–57.
2. Gian Paolo Lomazzo, *Trattato dell'arte della pittura, scultura ed architettura,* 3 vols., Milan, 1584; and idem, *Idea del Tempio della Pittura,* Milan, 1590.
3. "L'Autore a chi legge," Carlo Ridolfi's autobiography, appears at the very end of his *Maraviglie dell'arte, ovvero le vite degli illustri pittori veneti e dello stato,* Venice, 1648, II, pp. 306–24. For our translation and for all citations we have used the annotated edition by Detlev von Hadeln, published in Berlin in 1924.
4. Domenico Vitaliani, *Carlo Ridolfi, pittore e scrittore,* Lonigo, 1911.
5. Parish baptismal records list Ridolfi's father as Marco Sartor. Vitaliani makes the entirely reasonable suggestion that the family name was originally Rudolphus, that in Italy it was changed to Sartor as an occupational designation, and that Carlo changed it to Ridolfi, an Italianized version of the original name.
6. Ridolfi, *Maraviglie,* II, p. 298.
7. Ridolfi, *Maraviglie,* I, p. 207 (from the "Life of Titian").
8. For illustrations see Vitaliani, opposite pp. 65, 81.

9. Rodolfo Pallucchini, *La Pittura Veneziana del Seicento,* Milan, 1981, I, 79.

10. Illustrated in Pallucchini, II, Fig. 197.

11. Kruno Prijatelj, "Le opere di Carlo Ridolfi in Dalmatia," *Arte Veneta,* XXII, 1968, pp. 183–85.

12. Illustrated in Prijatelj, Fig. 271.

13. The canvas is signed and dated "Rodulphus Eques Anno DNI MDCLVI. See Sandra Moschini Marconi, *Gallerie dell'Accademia di Venezia,* Rome, III, 1970, p. 91, Fig. 192.

14. For Ridolfi's collection of drawings, see C. F. Bell, *Drawings by the Old Masters in the Library of Christ Church Oxford,* Oxford, 1914, pp. 20–22; Michelangelo Murano, "Di Carlo Ridolfi e di altre 'fonti' per lo studio del disegno veneto nel Seicento," *Festschrift Ulrich Middeldorf,* Berlin, 1968, pp. 429–33; K. T. Parker, *Disegni veneti di Oxford, catalogo della mostra,* Venice, 1958.

15. Parker, p. 12.

16. Francis Haskell, "La sfortuna critica di Giorgione," *Giorgione e l'umanismo veneziano,* Florence, 1981, II, p. 592.

17. Carlo Ridolfi, *Novella di Madonna Isotta di Pisa,* Venice, 1620. The work is apparently based on a poem by Andrea Volpino.

18. Carlo Ridolfi, *La Vita di Giacopo Robusti detto il Tintoretto . . . ,* Venice, 1642.

19. Julius von Schlosser Magnino, *La letteratura artistica,* 3rd edit. enlarged by Otto Kurz, Vienna, 1924, p. 531.

20. Ridolfi, *Maraviglie,* II, 308.

21. Filippo Baldinucci, *Delle notizie de'professori del disegno da Cimabue in qua,* (1st edit. 1681–1728), Florence, XVI, 1773, p. 77.

22. Luigi Lanzi, *Storia pittorica della Italia. . . ,* 3rd edit., Bassano, 1809, III, 216.

The Life of
Jacopo Robusti,
Called Tintoretto,
A Venetian Citizen
and Painter

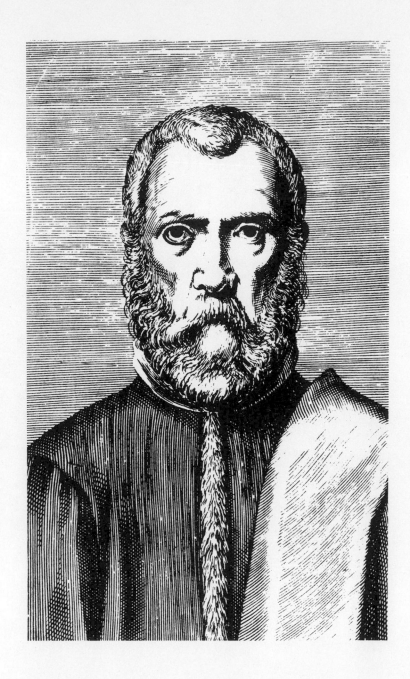

ne ought not, as some think, esteem that picture which is embellished with a rich display of colors, since the difficulty in painting does not lie in knowing how to lay out vermilion or ultramarine on panel or on canvas. Still less does the painter acquire the title of learned by weaving gems and ribbons in hair, or by embroidering silk cloth with arabesques. Nor does the perfection of so sublime an art end with the imitation of flowers, plants, and animals, since in pictorial compositions such things serve only to provide a bit of decoration and do not constitute the essential beauty of painting.

I, for my part, based on a clearer understanding of the matter, would say that all unreasoning plants and animals have certain pleasing forms, and may evince a certain superiority because of special qualities they may have or because of some more or less evident beauty. Yet they cannot

be praised for possessing the highest perfection of form in comparison to man. To man was given greater beauty and dignity and a harmonious symmetry, bringing him to a level of grace and decorum which (besides the possession of the most excellent proportions that are among inferior creatures diffused, and the faculty of reason, which is man's gift alone) render him superior to all created things.

Nor do these conditions make up the whole of his nobility, since as the preferred creature he had his being from the hand of the Eternal Creator, whereas the others were created with only a gesture of His omnipotence. But it pleased God to shape man out of clay, forming from it the skeletal framework, connecting it to the nerves, adding muscles, arteries, cartilage, veins, and the most delicate skin. Then He raised the forehead, formed the nose, opened the mouth, lowered the chin, carved out the ears, separated the hairs, curved the shoulders, broadened the chest, extended the arms, modeled the hands, drew out the flanks, made the thighs muscular, the legs sinewy, and placed them on the very strong base that is formed by the feet. And as the Supreme Painter, He dipped his brush in the whiteness of the lilies, the vermilion of the roses, and tinted the cheeks and the soft lips and all the rest of the body.

Nor did He here end his marvels, since by infusing in him the faculty of the intellect He made him an image of Himself, bringing him in such guise to the height of perfection. But since it was our intention to speak only of the visible forms, leaving aside the beauties within, it will suffice us to have shown how the human body, through the order of its creation and through the beauty of its parts, surpasses in nobility everything in the universe. Whence one may without difficulty conclude that if, in the ordering of nature, God did not make anything more beautiful or better than man, then the most excellent operation that can come from a diligent hand will be brought into being if he knows how to form the human body with just proportions, with gracious movements, and rare emotions. It is then that the painter will, without doubt, reach the most difficult aspect of his art.

Thus it will be our concern, however difficult the undertaking may be, to tell of the doings of the great Tintoretto, and through our narration to make his works known, to tell how he reached the arduous apex of art; and how with his brush he brought to the images that he painted the greatest state of perfection and how he adorned painting with the most novel and rare inventions, so that nature, which at times is defective, obtained through his hands grace and grandeur.

But before we become immersed in the sea of his many labors (through which anyone, however undiscerning, will clearly see that those things that we are setting out to describe are not exaggerated) let us speak of his birth and education.

Jacopo was born in Venice, the theatre of all marvels, in the year 1512. His father was Battista Robusti, a Venetian citizen, and a cloth dyer, from which the boy took the surname of Tintoretto [the little dyer]. As a child Tintoretto began to draw on the walls with charcoal and the colors of his father's dyes, tracing childish figures which nevertheless had about them some element of grace. His parents on seeing them deemed that it would be well that he cultivate his natural inclination, and so they placed him with Titian. While he was living with the other youngsters in Titian's house he managed to copy some of his works.

Not many days later Titian, returning home, entered the room where the students were, and on seeing some papers at the bottom of a bench with certain figures drawn on them, asked who had done them. Jacopo, who had made them, fearing to have done them incorrectly, timidly said they were his. But Titian foresaw that from these beginnings the boy might become a man of great merit. Scarcely had he climbed the stairs and laid aside his mantle than he impatiently called his pupil Girolamo (thus does the worm of jealousy affect the human heart) and ordered him to send Jacopo from the house as soon as possible. And so, without knowing why, Tintoretto was left without a master.

We can imagine the vexation he must have felt. But since such affronts sometimes become a spur to noble spirits and

give rise to great resolutions, Jacopo, moved by noble indig-
nation, gave thought, even though he was still a child, on how
to bring to conclusion the undertaking he had begun. Nor did
he allow his emotions to gain the upper hand, recognizing the
merit of Titian who was praised far and wide. In any case he
thought he could become a painter by studying the canvases
of Titian and the reliefs of Michelangelo Buonarroti, who was
recognized as the father of design. Thus with the guidance of
these two divine lights who have made painting and sculpture
so illustrious in modern times, he started out toward his
longed-for goal, furnished only with good counsel, to point
the way on his difficult journey. So as not to stray from his
proposed aim he inscribed on the walls of one of his rooms
the following work rule:

Michelangelo's design and Titian's color.

Next he set out to gather from many places, and with quite
an outlay of money, plaster models of antique marbles. He
had brought from Florence the small models that Daniele da
Volterra had copied from the Medici tomb figures in San
Lorenzo, that is to say *Dawn, Dusk, Day,* and *Night.* These
he studied intensively, making an infinite number of drawings
of them by the light of an oil lamp, so that he could compose
in a powerful and solidly modeled manner by means of those
strong shadows cast by the lamp. Nor did he cease his con-
tinuous study of whatever hand or torso he had collected,
reproducing them on colored paper with charcoal and water-
color and highlighting them with chalk and white lead. Thus
did he learn the forms requisite for his art.

Being of keen mind he knew well that it was necessary to
make drawings from carefully selected pieces of sculptures
and to avoid the strict imitation of nature which usually gives
imperfect results because nature never succeeds in achieving
equal beauty in all her parts. Tintoretto observed accurately
that the best artists selected from nature, improving on her
defective parts, so as to achieve perfection. He continually
copied Titian's pictures, and on them based his handling of
color, with the result that in the paintings of his maturity one
can see the fruits of the careful observation of his years of

study. Without allowing his ardor to cool, by following in the footsteps of the best masters he reached perfection with rapid strides. He set himself, moreover, to draw the living model in all sorts of attitudes which he endowed with a grace of movement, drawing from them an endless variety of foreshortenings. Sometimes he dissected corpses in order to study the arrangement of the muscles, so as to combine his observation of sculpture with his study of nature, taking from the first its formal beauty, and from the second, unity and delicacy.

He trained himself also by concocting in wax and clay small figures which he dressed in scraps of cloth, attentively studying the folds of the cloth on the outlines of the limbs. He also placed some of the figures in little houses and in perspective scenes made of wood and cardboard, and by means of little lamps he contrived for the windows he introduced therein lights and shadows.

He also hung some models by threads to the roof beams to study the appearance they made when seen from below, and to get the foreshortenings of figures for ceilings, creating by such methods bizarre effects.

On these foundations Tintoretto built the structure of his program, since to start out well in any discipline is, as some say, to progress in the study of it:

Beginning well is half the battle.

He also contrived, in order to gain practice in using colors (since study without practice does not suffice) to be wherever painting was being done. And it is said because of his desire to work that he even went with some masons to Cittadella, where he painted certain fanciful effects around the face of the clock, so as to unburden his mind which was filled to the brim with countless ideas.

He also practiced with painters of small success who decorated furniture for the painters in Piazza San Marco and this he did in order to learn their methods. He preferred, however, the painting of Schiavone, whom he willingly assisted without any recompense in order to learn that master's method of handling colors. Likewise he assisted him in Palazzo Zen at the Crociferi where, in a corner at the top, he

painted the figure of a reclining woman. And after some time he painted on his own the *Conversion of St. Paul* with many figures on the side toward the square, only traces of which remain. And in those early years he painted for the Compagnia de' Santi the *Life of St. Barbara,* a pictorial cycle arranged in a frieze around the walls, and also the figure of a *St. Christopher,* above the square, which is now completely gone.

Also during that period, which one could say was the golden age of Venetian painting, many youths of fine intellect and replete with talent made progress in their art and competitively exhibited the fruits of their labor in the Mercaria so as to find out the reaction of the viewers. And Tintoretto with his inventions and original ideas was also on hand to show the results that had been brought about in him by God and nature. Among the works he exhibited were two portraits, one of himself holding a piece of sculpture and one of his brother playing the lyre, both night scenes, which were depicted in so formidable a manner that he astonished everyone. Whence a noble spirit inspired by that vision to express himself in poetry wrote thus:

> If Tintoret's light at night appears so fine
> How shall his radiance in daylight shine?

He also placed a narrative painting with many figures in the Rialto. As soon as he got word of it Titian hurried over to see it and was unable to restrain his praises though the old rancor toward his despised pupil still remained. The power of talent is such that it draws praise from envy itself, which can do no less than celebrate that merit which sometimes appears in the enemy.

But let us briefly note those things that he did in the spring of his years, those first shoots from which will come the fruits of his maturity. Since at that time in Venice the only works that were praised were those by Palma Vecchio, Pordenone, Bonifacio and, especially, Titian, who usually got the most important commissions, there was no way for Tintoretto to

make his true worth known and gain public esteem except by working on public commissions with subject matter of greater import. Thus in order to overcome those difficulties which commonly impede unknown beginners he undertook all sorts of laborious tasks. There is no path more difficult to follow than that of virtue, strewn as it is with stones and thorns; and at the end the prize for such noble effort is approbation, which does not nourish and quickly fades away.

Among the things that Tintoretto undertook to paint were the organ shutters of the Servi, on which he depicted large figures of *St. Augustine* and *St. Paul* and on the inside part the *Virgin Annunciate*, and below *Cain Killing Abel* in fresco; and on the sides of an old altar in the chapel opposite he painted *Our Lady Annunciate with the Angel*.

In the Church of the Maddalena above the cornice he placed a painting of the *Preaching of Christ with the Penitent Magdalen*. And afterwards in another work he painted the *Magdalen* on her deathbed receiving communion from St. Massimino. In the Maddalena there are also portraits of priests of that church and a kneeling servant in a graceful pose holding a torch and stretching out an arm to support the Magdalen.

In San Benedetto he painted an altarpiece with the Virgin and several saints for the high altar. In another altarpiece he painted the *Birth of the Savior*. He also painted on the organ the *Virgin Annunciate*, and the *Woman of Samaria at the Well*. But when the church was restored the paintings were removed and only some of them have been put back.

Afterwards in Sant'Anna he painted a picture of the *Tiburtine Sibyl* pointing out to the Octavian Emperor the Virgin with the Infant Jesus who appears in a nimbus of glory within which a portrait is included. It is now placed on the altar of the nearby School. And in the Spirito Santo he painted a small altarpiece of the *Adoration of the Magi*. In the Carmine he painted the *Circumcision* which many believe to be by Schiavone because Tintoretto sometimes adopted that style.

About the year 1546 he painted in fresco the facade of the Casa de' Fabri at the Arsenal. There he depicted the *Feast of*

Belshazzar with the king and his followers at the table drinking from the sacred vessels and the finger writing on the wall "Mane, Thecl, Phares," the words which foretold the division of that Kingdom. It was that work which gave everyone the idea that in the field of art he would be a marvel.

Afterwards, as he grew in valor, he painted pictures that were more profound and erudite, such as the two pictures in Sant'Ermacora [Marcuola] of the *Last Supper* and the *Washing of the Feet of the Apostles* with beautiful perspective views; the latter however was removed and replaced by a copy. In San Severo he painted on a long canvas the *Crucifixion* of the Savior, placing therein a quantity of figures engaged in various activities. The Virgin is with the three Marys at the foot of the Cross, and there too are the soldiers who wager for the garments, who are in very natural positions, revealing a skillful sense of the structure of muscles in the areas where the body is unclothed. He made use of delicate and soft colors and exhibited a mastery of form from which we can comprehend how useful had been his study of the works of Titian and Michelangelo. It thus follows that Tintoretto is worthy of great praise since he knew how to avail himself of what he had studied and how to adapt it to his own use, thus forming a style that was skillful and overflowing with beauty, because of which he was admired and revered by the masters of his profession.

Later in SS. Trinità he did five paintings of the *Creation of the World*. And among them is the very celebrated scene wherein he painted the error of our earliest forebears when, persuaded by the Serpent, they eat the forbidden fruit; and that of Cain killing his brother. In the other he painted the creation of the fishes, the animals, and Eve.

Tintoretto used to say when talking about those paintings that he drew the body with great diligence from life, putting over his models a string gridwork so he could observe precisely the various parts of the limbs. He increased to some extent the beauty of the outlines, however, as he had learned to do from his study of sculpture, without which emphasis figures are little appreciated. And in those nudes he used to

say he wanted to demonstrate the way that must be employed in making life drawings. Those bodies would never have been brought to such a rare beauty if he had not supplemented that which nature lacked. The good painter must, he made clear, increase the beauty of nature with his art.

It was still the custom in Venice as we have noted to decorate the houses with frescoes, some of which are still preserved, for which those families deserve praise. Since a house was being built at the Angelo bridge it seemed to Tintoretto to present an opportunity to demonstrate his ideas. Talking it over with the masons, to whom was often given (as we touched upon in the *Life of Schiavone*) the charge of providing the painter, he was told that the owners did not want to spend anything on it. But he, who, in any case, was determined to paint it, decided to do it for the cost of the colors alone. When that was reported to the owners they with some further difficulty agreed. Thus does unhappy virtue find no resting place.

Having obtained the commission, he wanted to give full play to his talent. In the lower section he painted a battle with knights mounted on raging horses. Across the facade ran a cornice held up by simulated bronze hands and feet. Above this he painted a historical scene and a frieze with many figures; and on the top between the windows he represented several women arranged in beautiful attitudes, in each part demonstrating the skill and liveliness of his genius, so that even the painters themselves were amazed.

A similar caprice came to his mind while painting the small house of a dyer at the bridge of San Giovanni Laterano. There he represented a nude Ganymede being carried off by Jove who had assumed the guise of an eagle. Nor did he here consider representing a soft and delicate youth as described by the poets' pens, but only to express the condition of a muscular boy full of feeling, and he painted him in such a way that he could not be limned more boldly.

And since his fertile genius bubbled continuously with ideas, he was always thinking of ways to make himself known as the most daring painter in the world. So he proposed to the

fathers of the Madonna dell'Orto to paint two large pictures
for the chapel of the high altar, which was fifty feet high. The
Prior, deeming that a year's revenue would not be sufficient
for such an undertaking, laughingly dismissed him. But Tin-
toretto, without losing his poise, added that he asked for this
work only enough payment to cover his expenses, and that he
wished to make them a gift of his labor. The wise Prior, on
thinking it over, decided not to let such a fine opportunity slip
by and so he concluded an agreement with him for one hun-
dred ducats.

When the report of this agreement was spread about it gave
the established painters grounds for jeering, seeing the man-
ner in which Tintoretto appropriated the most conspicuous
commission in the city, though he had no current testimonials
affirming his ability; when art is reduced to such terms it is
harmed not a little.

There is no doubt that every profession is enhanced by
decorum and reputation, and this is true in particular of paint-
ing. Nor is it likely that the works of any painter, though they
may be excellent, can attain the level of the sublime if they
are debased by their author. Applause converges on the finest
outward show, and the world deems the height of perfection
to be found where the treasures are most lavish, since it is our
nature to be tyrannized by desire. But Tintoretto did not
know how to profit from this practice. As a result the ground
he sowed with great labor yielded but a small harvest, though
by right it should have brought him comfort and fortune.

But he gave little heed to the painters' complaints since his
efforts had no goal other than satisfaction and glory which,
though devoid of profit, is worthy of praise. Now let us go on
to speak of his paintings. In one he represents the detestable
deed of the Hebrews, who, in return for favors received from
the lavish hand of God, set up as an idol the *Calf of Gold* (the
sin of idolatry may be said to be more detestable than any
other since it amounts to the denial of God Himself). In full
view of the people and with solemn pomp the Hebrews carry
the idol on a platform furnished with handles and adorned
with gems; and following it is a festive group of men and

women carrying branches and cymbals. Among those in the forefront is a woman dressed in blue who points out the idol to the others. The grace and skill of this figure are indescribable. In one corner stand some aged craftsmen with the square and compass in hand, pointing to the idol they have made. On the steep slope of a nearby mountain we see countless women who as a sign of joy have hung lengths of silk on the mountain and who strip from their necks and ears pendants and jewels to give to what they believe to be a deity. Meanwhile on another high precipice encircled by dark clouds is Moses receiving the laws from God who is sustained by a group of nude angels arranged in graceful and elegant attitudes.

I will forgo describing the order of the composition, the study, the energy, and drawing put into the limbs of the bearers, for such abundant and erudite inventions cannot be restricted to a few words, nor can one believe that the author in undertaking such an enterprise was activated only by a desire for glory.

In the other painting Tintoretto represented the *Last Judgment* which captures the terror and fright of that last day. At the top is Christ the Judge, with the Virgin and St. John kneeling before him, plus the Good Thief with his cross on his shoulder, and facing him the Theological Virtues which are means of shielding oneself from divine wrath. The saints are seated on the many circles of clouds in the midst of which angels descend blowing the trumpets to wake the dead to Judgement. On the left side is a mass of men and women who fall headlong, driven out by St. Michael's gleaming sword. And since Tintoretto also wished to show the resurrection of those whose grave was in the waters, with extraordinary originality he painted a far off river full of bodies flung about on its waves. There too he represented Charon's bark filled with the damned who are being taken off to Hell by demons who look like wild beasts and horrible monsters. And as he wanted to show the resurrection of bodies in a natural way, he painted some in the foreground that had already taken on flesh. Others with skulls for heads and from whose arms

sprout leafy branches, are rising up from the earth; others spring up violently from their sepulchres, and many others, jumbled together with demons, fall into the Abyss.

Here the pen can only give a faint idea of such an extravagant and abundant invention, since to describe the countless poses of those figures, the power of the bodies, the art employed in the rushing of the river, and the many learned observations that appear would exhaust the talent of any bold writer. Works that are prodigious may in some way be indicated by the pen although they cannot be fully described.

On the outside of the organ wings he then painted Our Lady as a child who majestically climbs the steps of the temple where at the top the Priest stands to receive her. And on the steps he arranged many figures that gradually become smaller as the stairs recede. At the bottom is a woman standing with her back turned pointing out the Virgin to her daughter. Her movement and grace are beyond description. On the inner part of the organ wings he painted four flying angels carrying the Cross to St. Peter, who is seated and wears pontifical robes. On the other wing is the kneeling St. Christopher awaiting the blow of the executioner's sword. Pieces of armor are on the ground and a very joyful angel with palm in hand descends from the sky. These events, and the artistic elements with which they are adorned, were beautifully painted by Tintoretto.

Next, in the chapel of Cardinal Contarino, he painted the altarpiece of *St. Agnes* who, accompanied by a group of noblewomen of comely visage and elegantly clothed, brings back to life by her prayers the Prefect's son who fell dead when he wanted to do her violence. Here we admire the perfection of Christianity, which for injuries received returns acts of mercy. The composition is enriched by distant views of colonnades and angels who witness the miracle.

But let us go on to discuss works that are still more complex. With the opportunity afforded by the many excellent painters who then flourished in Venice, the churches and the chambers of the confraternities were adorned by new paintings, works which improved on the crude old-fashioned man-

ner of painting that was used by painters of the past, whose work does little to please the eye. It happened that some of the administrators of the Confraternity of San Marco met with Tintoretto and commissioned him to do a painting about twenty feet square of a miracle of St. Mark. The subject deals with a servant of a knight of Provence who against his master's will departed to visit the relics of St. Mark. On his return the knight commanded that in expiation for his transgression his eyes should be put out and his legs broken.

Here then Tintoretto painted the servant amid broken pieces of iron and wood prepared for the torture; and in the air we see, brilliantly foreshortened, St. Mark coming to his aid, and he remained unharmed since the saints do not fail to protect in their tribulations those devoted to them. Bearing witness to this great miracle are many people dressed in robes with barbaric ornaments, and also soldiers and functionaries in attitudes of amazement. One of them shows the hammers and splintered wood to his lord who is seated above, overcome with wonderment. There are also some people clinging to columns, and among the marvels of that marvelous composition is a woman leaning against a pedestal and bending back in order to see the action, who is so alert and vivacious that she seems alive.

For this incomparable picture it suffices to have lightly sketched in the concept, since Fame with everlasting acclamation unceasingly spreads its honors, and every learned and perceptive person that comes to see it affirms that here are reached the outward limits of the art.

But since virtue always encounters difficulties it came about that differences of opinion arose among the members of the Confraternity, with some wanting the painting to remain on display and others not. Hence Tintoretto became angry and had the picture taken away and brought back to his house. Finally the uproar died down, and the adversaries, seeing themselves jeered, and realizing how much they were giving up through the loss of that painting, which was universally acclaimed as a marvel, were forced to ask him to bring it back. And in the end, after keeping them in suspense for

some time he replaced it. They then assuaged his anger by commissioning him to do three more paintings for their rooms, and these he completed in the following way.

In the painting in the first room the scene is set in Alexandria. There we see the *Removal of the Body of St. Mark* which Buono da Malamocco and Rustico da Torcello, Venetian merchants, had obtained from Greek priests. In a long colonnade we see lining the wall many sarcophagi in excellent perspective, from which many bodies are being lifted. On the ground is the body of St. Mark arranged in such a position that it follows the eye wherever it turns. Tintoretto has, moreover, ingeniously represented in the painting a man possessed, in whom we see the frenzy that the Devil causes in humans, as often happens when saints' bodies are moved.

In the second picture the body of the saint is carried by the said merchants to the ships. In the distance we see dark clouds with lightening descending, and driving rain and the Spirit of St. Mark in the form of a cloud leads the way. From it the frightened Alexandrians, aroused by the perfume strewn in order to prevent the discovery of the body, flee into the nearby colonnades. One of them, who is half naked, tries to conceal himself in his mantle. In the meanwhile the pious porters have an opportunity to bring safely to the ship their acquired treasure.

The third painting is of a storm at sea when St. Mark saved a Saracen from the waves. The Saracen, along with other infidels, was on a voyage to Alexandria when the ship was wrecked by the fury of the winds; he invokes the name of the Saint, who transports him to the skiff where the Venetian merchants had taken refuge. We see that small craft battered by the tempest and the terror of the shipwrecked sailors who pull the oars, fearing all was lost. By that trust the Saracen was rescued from the perils of the sea, for faith has such power that even barbarian breasts are filled with the grace of God. Nor could another brush with greater skill reveal the mood of such a miracle, marvelously magnified by his art. And among the sailors he painted the celebrated philosopher, Tomaso da Ravenna, in the ducal dress of gold.

With the name of Tintoretto, now well-known, rendered illustrious by his many works, the Venetian Senate wanted him to paint some works in the Sala del Maggior Consiglio. From time to time the old scenes that had been painted in an earlier age by Pisanello, Vivarino, and others, and which had been in part repainted by Giovanni Bellini, his brother Gentile, Titian, and other artists, were being redone.

He thus was given the charge of painting the history of the Emperor Frederick receiving the imperial crown in Rome from the hands of Pope Adrian. He represented therein with much decorum the papal court, with cardinals, bishops and Venetian senators, among whom were Stefano Tiepolo, Procurator of St. Mark's, Daniel Barbaro, Grimano, the Patriarch of Aquileia, and other noble Venetians. And underneath was the inscription:

POPE HADRIAN BESTOWED ON FREDERICK BARBAROSSA THE INSIGNIA OF THE ROMAN EMPIRE IN ST. PETER'S.

And since a little later Veronese contributed a painting for this same hall, Tintoretto arranged it so that he too obtained another commission (for it seemed to him that he had accomplished little in the previous work, which was the fourth from the entrance to the Consiglio). In this painting he represented Pope Alexander III with a number of cardinals and prelates in the act of excommunicating the Emperor. He showed the horror and fear which such a malediction usually brings about in the bystanders. He painted the pontiff in the act of casting the extinguished candles among the crowd. And in order to vent his fancy, for ordinary ideas did not satisfy him, he invented a scuffle among the common people who vie for the candles that were flung down among them. Every part of the painting he executed with the highest diligence and precision, so that it was proclaimed by everyone as something altogether extraordinary. Scattered throughout the canvas were portraits of Marchio Michiele, the Procurator of St. Mark's, Michel Suriano, and other illustrious personages

whom, for the sake of brevity, we will not mention. And at
the bottom of the scene we read:

> POPE ALEXANDER, HAVING BECOME AWARE
> OF FREDERICK'S INSOLENT ACTS, BOTH
> PRESSED HIM IN SILENT WAR AND DROVE
> HIM AWAY WITH ANATHEMA. HIS DEEDS
> HAVING BEEN PLACED UNDER ADVERSE
> EDICT, FREDERICK'S KINGDOM WAS ALIEN-
> ATED FROM POPE ALEXANDER.

Then in the Sala dello Scrutinio he painted *The Last Judg-
ment*. Christ the Judge is in the center borne by a group of
nude angels and flanked on either side by the inhabitants of
Heaven. The Elect, on the right, intermingled with angels,
are rising up to glory, while the Damned, on the left, are
pulled by furious demons down to Hell. In this section he
included a quantity of nude bodies skilfully arranged in vari-
ous poses. Such was the theme that inspired the painting that
struck terror in the hearts of those who saw it. But this great
work, together with the other two paintings just mentioned,
was destroyed by a fire in the palace in 1577.

But let us go on to San Rocco, where Pordenone had fres-
coed the apse. Tintoretto painted two histories in oil there at
the top of the walls, one of the *Conversion of St. Paul* and the
other of *St. Roch* visited by wild animals in the desert. Then
below he added two other paintings, about twenty-four feet in
length, which are of even greater perfection.

One of these shows St. Roch in a hospital curing with the
sign of the cross a plague-stricken man who lifts his leg to
show his wound. The rest of the hospital is filled with sick
men and women. Some who have climbed up on the benches
unbind their wounds. Others are seen weakly lying on the
ground in poses so marvelously foreshortened that it appears
that their feet are coming out of the painting. Some old men
are held up by youths, and women rise up from their beds to
implore the saint's mercy.

This painting which is celebrated for the originality of its

composition is worthy of all the praises that can be given to a work of the highest perfection. Each of its parts portrays a sadness so appropriate to the place that it arouses in men's hearts feelings of pity. The perfection of its design and the excellence of its color are such that those bodies do not seem to be composed of oil paint, but formed of living flesh. Nor did envy ever find room for attack, since in the opinion of all who are well-informed in these matters there could not be anything more skilfully done.

The other painting shows the Saint stricken by the plague lying in bed where he is visited and consoled by a joyous angel dressed in the most lovely robes. The arrangement of that composition is particularly worthy of commendation. In it are some chained madmen with wooden locks on their feet, and still others (besides the sick) who poke their heads out of the iron grills set in the floor to whom the attendants bring food, the whole of which forms the most curious invention one did ever see. But since in their multiplicity and singularity Tintoretto's inventions are impossible to explain, we can excuse the defect of the pen that cannot fully represent them with its strokes.

In the middle of the church on the doors of a large cabinet (where the votive offerings of the devout are kept) Tintoretto painted (in competition with Pordenone, who painted a similar picture facing it) *Christ Commanding the Paralytic to Take Up His Bed and Walk*. Nor is this a less precious painting than that aforementioned, since it is enriched by the grace that is brought to it by the artist, every stroke of whose brush adds to his immortality a bit of glory. And on the doors of the organ he painted *St. Roch* receiving the pope's benediction in Rome, and on the opposite side the *Virgin Annunciate*.

Just about the same time work began on the paintings of the vault of the Libreria of St. Mark's. Titian had from the procurators the charge of distributing the paintings amongst Schiavone, Paolo da Verona, Battista Zelotti, Giuseppe Salviati, Battista Franco, and other young men who were considered to be talented, but Tintoretto was excluded. Later, however, Tintoretto obtained from the procurators them-

selves the commission to paint some figures of philosophers on the walls. Among them is a seated nude, *Diogenes,* who is painted so powerfully that he seems to stand out from his niche. It is in fact a stupendous figure, both in the quality of the body, which is drawn with the greatest care, and for the lifelike treatment of his pose. Diogenes is deep in thought, with his legs crossed and his chin on an arm that rests on his thigh. In this figure we sense the profound concentration of the philosopher. By the excellence of this painting Tintoretto avenged the wrong that Titian had done him and showed clearly how unfair he had been.

But let us continue to speak of the paintings of San Rocco. The seat of the Confraternity, which was formerly located near Santo Stefano, beyond the Grand Canal, was transferred in 1488 to a site near the Church of the Frari. There with a lavish expenditure of funds a new seat was built on the plans of Jacopo Sansovino, Florentine architect and sculptor.

In about the year 1560 the members of the Confraternity thought of acquiring an outstanding painting for the Albergo section of their building. To this end they sought the best painters of the city, among them Tintoretto, to make a design for the central oval panel. But Tintoretto secretly obtained from the servants the measurements of the space, and while the others were working to make their designs he with admirable speed did the painting itself, which depicts *St. Roch in Glory* received by God the Father and attendant angels who hold the attributes of his pilgrimage; and without a word to anyone he put it in place.

The day after, Veronese, Andrea Schiavone, Giuseppe Salviati, and Federico Zuccaro were to appear to show their designs and Tintoretto was sought out to explain his as well; he had the painted canvas, which had been skilfully hidden with cardboard, uncovered, and said that this was the design he made, about which there could be no error, and if his quick work did not please them he would make a gift of it to St. Roch, from whom he had obtained many favors. The painters were dumbfounded to see such a beautiful work carried out with such elegance in the space of a few days. Gathering up

their sketches they said to the members of the Confraternity
that they could no longer have any claim to the commission,
since Tintoretto through his valor had gained the honor.
Nevertheless, the members of the Confraternity were angry,
and insisted that his painting be removed because they had
given no such order, but only wanted to see a sketch of the
composition in order to give the work to the one that pleased
them most. But being constrained to keep it (being unable
because of their rules to refuse anything donated to the
Saint), and since it was in actual fact considered excellent in
the highest degree, and since, moreover, the majority of the
votes were in favor of Tintoretto, it was agreed that he should
be worthily recompensed. Receiving him into their order,
they decreed that he alone would be given the commission for
the rest of the paintings that would be needed for their rooms.
He was given an annual provision of one hundred ducats for
life, in return for which he was required to furnish one com-
pleted painting every year. But Tintoretto managed to dis-
patch them as quickly as possible, so that he drew his yearly
pension for a long time after the paintings were completed (in
his old age he used to say in jest that he wanted to live a
thousand ducats longer). Then to complete the aforemen-
tioned ceiling he painted the insignias and habits of the six
great schools of the city, including that of San Rocco.

He then went on to provide, within the space of the Al-
bergo, the paintings of the principal events of the *Passion of
Christ*. To the left of the entrance he placed a canvas which
shows *Christ before Pilate,* wrapped in a cloth of linen. With
such grace and divinity is He endowed that we can believe we
see God incarnate. But what makes that figure still more ad-
mirable is the delicacy with which Tintoretto arranged the
convolutions of the drapery, and the gentleness he imparted
to the movement of the limbs and the face in which he ex-
pressed the divine mercy of the Redeemer.

But here while we prepare to describe such an exceptional
painting the hand halts, since mortal pen is not equal to so
heavenly a concept.

Above the door he painted the pitiable spectacle of the

Savior shown to the people by Pilate. And in the right corner
he is shown being led over the top of a mountain to Calvary,
accompanied by a group of soldiers. And with a fresh idea he
added the two thieves with the crosses tied over their shoul-
ders as they follow the exhausted Redeemer along the base of
the mountain.

For the principal wall, in the place where the members sat
during their meetings, he painted on a great canvas the
Crucifixion, wherein he related every important event nar-
rated by the Evangelists. Here we see at the center of Calvary
the Crucified Savior. At the bottom the Virgin Mother, over-
come with grief, collapses on the three Marys, who likewise
are in agony, as St. John and the Magdalen sorrowfully gaze
at the cross. Meanwhile an attendant who has climbed a lad-
der that is leaning against the cross is immersing the sponge in
vinegar and gall to increase with this bitter brew the pain of
the thirsting Redeemer. In the left part some of the execu-
tioners furiously stretch out on one of the crosses one of the
thieves who is nude. One grips the thief's hand in order to
nail it, another drills the foot of the cross, while others pro-
vide the nails and gather up the rope. On the right we see the
other thief, who is already crucified and is being lifted up by
means of a long rope, through which Tintoretto expresses the
muscular effort required by that action. Amongst the broken
stones in the midst of the mountain are three soldiers who,
having set aside their crossbows and spears, gamble over
Christ's garments. Every part of Calvary is full of horror, of
soldiers, and of government agents who have portioned out
the tasks, and also groups of cavaliers on well-caparisoned
horses. Lances, flags, and insignias of Roman rule surround
the Mount. A multitude can be seen still coming out from
Jerusalem, some on mules and some on foot, in order to see
the spectacle of the hanging Savior. To sum up, Tintoretto
did not leave out anything that might be lifelike in that event,
or that could arouse emotions of compassion in the onlooker
as he beheld that tragic event. And, truly, in the repre-
sentation of the mysteries of our sacred religion one should
strive to reveal them so as to arouse devotion rather than

laughter, as is sometimes the case. In a corner of the painting Tintoretto inscribed thus, both the name of the Guardian of the School and his own:

M D L X V.
WHEN JEROME WAS THE
DISTINGUISHED LORD OF THE ROTA
AND COLLEGE.
JACOPO TINTORETTO
MADE IT.

But we will not pause to recount the praises of this immense and noble work, which would be like bringing light to the sun, since the celebrated engraver Agostino Carracci has made it known to one and all by translating it with the highest skill into a print, thus making it easy to see the beauties with which it is replete. They say that Carracci brought a copy of his engraving to Tintoretto who, when he saw how well he had been served, embraced Agostino with great emotion and praised him extravagantly. Carracci on his part was proud of having acquired whatever good he possessed from the works of so great a master. Nor were his engravings ever admired as much as when they were enriched by Tintoretto's compositions.

Passing now from the Albergo into the Great Hall, we will briefly touch on those works that Tintoretto went on to paint in accordance with the task he had undertaken. Starting with the group in the middle of the ceiling, he began work with an oval in which he represented *Adam and Eve* who, not heeding the divine precept, ate the forbidden fruit. Next follows a picture of *Moses Striking the Rock* and making gush forth in abundance the waters which a numerous crowd of stricken people collect in large basins and jars. With such a prodigious miracle did God wish to show the special protection that He gave to that people, bringing forth for them drink from the very stones. The act of bringing water out of rock should be enough to keep in faith even the most barbarous of nations, not to speak of a favored people. But the Hebrews, always

ungrateful, turned their face against their Creator for any reason, however slight.

In the second oval we see *Jonah* on the beach, spewed forth by the whale so he could continue his journey to Nineveh in accordance with divine command. And in the middle picture, which is about twenty braccia [c. seven meters] in length, he painted the *Brazen Serpent* which Moses shows to the people in the desert. In this abundant composition we see many learned solutions that the painter used in diversifying the bodies of the various figures that, having been wounded by the serpents, twist about in strange attitudes, several gripping the serpents with greater or lesser muscular power in conformity with their various physical states. One notes as well the marvelous skill he used in separating one figure from another with light and shadow so that they stand out to varying degrees, the distant figures being made to fade away with the greatest delicacy. At the top we see God the Father borne by a multitude of nude angels. Tintoretto only knew how to paint his figures in the most expert and vigorous way. But, leaving these considerations to the curious, let us go on with our discourse.

Next to it, in the third oval, is the obedience of Abraham in sacrificing his son. In the third picture he painted the *Fall of Manna* which the lavish hand of God provided for the Hebrews in the desert. Among those who gather up the manna is a standing man holding a large basin, whose pose is such that it fills those who see it with wonder. The central series is brought to a close with the *Sacrifice of the Lamb,* which is in the last oval.

In six other spaces, these being rectangular in shape, Tintoretto painted scenes from Sacred Scripture: Moses leading the Hebrews through the desert with the guidance of the *Pillar of Fire; Jacob's Ladder;* and some *Visions of the Prophets Elijah and Ezekiel.*

Ten large pictures were then arranged around the walls of the same hall with subjects from the New Testament. In the first is the *Birth of Christ,* which has a highly original composition, the Virgin being placed in the loft of a stable with St. Joseph nearby and the adoring shepherds. On the floor of the

rustic hut others are seen bringing to the newborn God pastoral gifts, and receiving the light that radiates from the face of the Virgin and the Divine Infant. In the painting that follows Christ is baptized in the Jordan. In the distance we see a long line of people coming to be baptized. In the third, the Redeemer arises from the sepulchre. The stone has been lifted by four angels whose rapid movements cause their lovely robes to flutter in graceful scroll-like shapes. The soldiers stand guard, wrapped in mantles and shadowed by the cloud that encircles the Savior, so that we can make out of them only a few highlights, strokes at the top of the head and on the knees. These devices were often used by Tintoretto to give greater force to the composition and to emphasize the parts touched by the light. In the fourth painting is represented the *Agony of Our Lord in the Garden*. The angel who appears to comfort Him is encircled by a great radiance that sheds light on the composition. In the fifth we behold *Christ's Supper with the Apostles*. They are seen from a highly unusual point of view in a ground-floor room, the scene being shown with naturalness but also with an awesome quality.

On the opposite wall there follows the Miracle of the Savior's *Multiplication of the Five Loaves and Two Fishes*. It is an example of Divine Providence which provides in abundance to those who direct their hopes toward Heaven. Here we see the Savior on the slope of a mountain pointing to the Apostles who are distributing the bread that the youth has gathered. At the foot of the mountain are arranged several large figures which are painted in a bold and resolute manner. The seventh painting is of the man who was born blind and is being led to Christ. The eighth is of the *Ascension* into Heaven. In the ninth is the pool with gracious pergolas drawn in perspective, where Christ commands the paralytic to walk. The last picture of that series is Our Lord being tempted by the Demon. We can no longer say the Devil is deformed, for here Tintoretto painted him in the guise of a beautiful youth with elegant tresses and bracelets on his wrists. At the top of the hall between the windows are inset the figures of *St. Roch* and *St. Sebastian*.

And finally, at the altar, he placed a canvas showing *St.*

Roch appearing to the sick. In one corner he portrayed the British Cardinal, his guest in Rome, who was blessed by the Saint at a time when the city was tormented by the plague. The imprint of the cross remained on his forehead, protecting him from that sickness. And above the arch through which one passes to the second stairway Tintoretto placed a painting of medium size in which is depicted the *Visitation* of the Virgin to St. Elizabeth.

In the hall on the ground floor he arranged in much the same way the following scenes. We see in the first space the *Virgin Annunciate* who speaks with the Angel of the high mystery of the Incarnation while St. Joseph labors at his tasks in the background. He portrayed a room divided by a wall whose broken bricks are realistically depicted. In the next picture the newborn Savior is adored by the Magi, while in the distance servants are leading camels laden with baggage. In the third the Virgin flees to Egypt, holding closely in her arms our Infant Savior who is wrapped in swaddling clothes, while St. Joseph leads the donkey through a wooded area with beautiful views in the distance. In the fourth he represented the *Massacre of the Innocents* which is perhaps the most original composition of the whole group. In it several women with disheveled hair are crying out and clasping their children tightly to their breast as they hurl themselves over a wall in an effort to escape from their executioners. Others have fallen on the ground, and among them is one who in an act of self-sacrifice grasps the sword of the executioner in an attempt, by wounding herself, to save from his cruel hands the tender young child she holds to her breast. The last two paintings are of the *Circumcision* of Our Lord and the *Assumption* of the Virgin, in which the Apostles at the tomb show by their gestures their awe on seeing their Queen ascend to Heaven.

From these abundant and erudite compositions numberless artistic precepts could be garnered by showing the many skills employed in them. But since it was not our intention to write about the rules of painting, but only through a discussion of the works themselves to touch upon some of the skills

and beautiful effects the artist used, we will not go beyond that point. We cannot, however, pass over in silence the honors due to Tintoretto, since we can truly say that the Scuola of San Rocco was ever the academy and home of all students of painting, and in particular of those from beyond the Alps, who from that time on have come to Venice. His works have served as exemplars leading to an understanding of how to compose with originality, how to give grace and conciseness to design, how to provide order by isolating, with lights and shadows, groups of figures within the composition, and how to give freedom and strength to the colors of the painting, and, in short, to do whatever is needed to make more effective the artist's creativity. Certainly those works were not painted negligently by Tintoretto, as is believed by some who are ill-versed in the beauty of art and do not see in them a certain gradation of shading of the colors that would satisfy the eye of the less well-informed. The use of refinements and finishing is not always praiseworthy in a painter. It is undoubtedly superfluous in those compositions that are placed far from the viewer so that the intervening atmosphere unites with an extraordinary softness the bold brush strokes, rendering |them soft and pleasant when seen from a distance. Therefore Tintoretto is commended by wise artists for being able to visualize the effect that the paintings would make in their assigned location, employing a finish sufficient and proportionate to the site, and always using in a masterful way his style of bold brush strokes which, in short, is the goal that is so difficult to achieve for those who want to make themselves thought of as great in art. It comes from long experience and from the keenness of intellect which in that extraordinary Author was unique.

We add in praise of these famous paintings that many talented Flemish engravers (not to mention Carracci) have added to his fame by translating into print those precious ideas. Among them are Egidio Sadeler, who engraved the *Resurrection of Christ* in royal folio, and Lukas Kilian, who engraved the *Massacre of the Innocents* and the *Miracle of the Loaves and Fishes*. There are also engravings of the *Vir-*

gin Annunciate, the *Circumcision,* and other narratives of
that series which those wise artists made, knowing the
usefulness they would have for the scholars. And that is not
to mention the countless drawings and painted copies of
those works which were made by students. Tintoretto was
able through the lofty level of his thoughts to stimulate all the
intellects of his age, leading them through felicitious paths to
become splendid and grand. And in Venice, where it seems
that God blessed this art in a special way, all those who came
after him were said to follow the style that he used in his
compositions, in his poses, and in the great strength and en-
ergy that he expressed through his figures, and in those con-
cepts we touched upon in our account of his works which
confront the most difficult aspects of art.

That manner, followed with much diligence and praise by
painters of the past and admired by connoisseurs of painting,
one can still see practiced by learned Venetians; there being
no need to search for novelties in the far reaches of the earth,
since those painters did not lack valor sufficient to satisfy the
curiosity of the world when it could be persuaded that the
valor of the painter is not due to luck, and that outward forms
and ostentation often attract those who are more satisfied
with opinion than with truth.

During this period Tintoretto made for Don Guglielmo, the
Duke of Mantua, eight large decorative friezes for the rooms
of his castle in which were depicted the principal events of
that family. He represented the *Battle of Taro,* led by
Marchese Francesco Gonzaga, and other victories won for
the Venetian Republic. He also portrayed the ceremony by
which the Emperor Charles V conferred the title of Duke, as
well as other events in the history of the Gonzaga family.
While working on the friezes, Tintoretto was often visited by
the Duke, who was in Venice at that time. Don Guglielmo
took the greatest pleasure in watching Tintoretto paint. The
Duke enjoyed his gentle manners, for the artist was able with
the greatest grace to adapt himself to anyone, and was espe-
cially adept at the gentle art of dealing with the great.

When the friezes were completed he was invited by the

Mantuan Ambassador, in the name of the Duke, to come to Mantua with the paintings in order to assist in placing them in the spaces where they were to go. Tintoretto, who in fact welcomed the opportunity to go to Mantua with his wife to visit the family of her brother who lived there and was much loved by the Duke, said he could not go, and begged the ambassador to present his excuses to his highness. On being asked why he refused, he replied that his wife wanted to go with him no matter where he went. When he heard that the ambassador said that he would not fail in his service to his lord, the Duke, and that Tintoretto could take not only his wife but his whole family. Having ordered that one of the small ducal barges be well-furnished with provisions and made ready for him, Tintoretto set off for Mantua with his wife. There he stayed for many days at the court, where he was welcomed by the Duke with much kindness and munificent expenditure. The Prince often spent time with the painter, discussing with him some of his ideas for buildings and new projects for the city. And he put Tintoretto's counsel into effect, as one can only receive useful precepts from wise painters, because that art embraces all knowledge pertaining to design. The Duke also wanted Tintoretto to remain at his court, but because of the many public and private works that the artist had left unfinished in Venice, he was unable to stay. Another reason was because it was always irritating to him, as an honorable man, to feel himself bound by chains even though they were embellished with gold and jewels.

To remind posterity of the victory that the Republic won against the Turks in the year 1571, the Senate decided to have a representation of that glorious event in the Sala dello Scrutinio. They gave the commission to Titian and also assigned Giuseppe Salviati as his partner in order to lighten the load. But for whatever reason (and here the reports disagree), the beginning of the work was continually put off, thus giving Tintoretto, who wanted to execute every painting for the city by himself, a chance to get the commission. He therefore went to the Collegio, and told the Doge and Senate that as a good citizen of Venice he had always harbored an immense

desire to show by deed to his Prince his affectionate heart. This then he would demonstrate by creating with the lights and darks of his paints that glorious victory which was won by the force of Venetian arms to the great applause of the world. He said also that with his mute brushes, in the guise of tongues, he would add to the general joy, and he promised to render every good service without recompense, deeming the praise of having well served his Prince to be enough payment. He added also that he promised within the space of a year (notwithstanding the many projects he had on hand) to turn over the completed work. He further pledged that if any painter in the space of two years could bring to completion a similar undertaking, he would yield the field and would promptly take down his painting if a better one were put up. Such resolutions do not enter into base hearts, but only into generous spirits that aspire to great honor.

The Senate, therefore, being well aware of Tintoretto's already proven worth and seeing that little advantage could be drawn from Titian, who was burdened with age, decided to give him the commission. He portrayed that great and glorious victory in such a way that we can see in it the main events. Among these are the capture of the galley of the Turkish General Ali Pasha, and the lifelike portraits of Sebastian Veniero, the Venetian General, and Don Juan of Austria, as well as Marc Antonio Colonna, who sailed for the pope and rallied the warriors who were exposed to the battle's greatest danger.

He likewise showed the wounding of Agostino Barbarigo, the Venetian Provveditore, who was struck in the eye by an arrow that cost him his life (those crimson drops adorn his name with eternal glory). He also showed many clashes of galleys filled with soldiers, and, hurling clouds of arrows, a horde of Turks, many of whom through the action of the battle fall into the sea and drown. He also painted other galleys in the distance which were skilfully illuminated by the fire of mortars and arrows streaking through the air. These far-off galleys the artist painted in this manner in order to thus separate them from nearby vessels, ingeniously veiling them in mists and dark clouds. In the same way he laid out on the

plains a great multitude of soldiers with spears, swords, bows, cross bows, and other instruments of war which make a cruel slaughter of the enemy. In short he arranged everything in that grand medley without confusion and in accord with the accurate precepts of art. Tìtian scorned this excellent work, as did his followers, who had a great hatred of Tintoretto because he interjected himself into all their affairs. In truth they had no greater obstacle to fame than him. His brush was, so to say, a thunderbolt that terrified everyone with its lightning. But the Senate, in order to respond with gratitude to such a great service, decided to reward him with an annuity to be passed on, with other benefices, to his descendants.

For the visit of Henry III, the King of France and Poland, Tintoretto painted together with Veronese some figures in chiaroscuro in the arch built on the Lido, after the design of the architect Andrea Palladio. But since Tintoretto had arranged to paint the portrait of the king whose arrival was awaited momentarily, he sought to get away, requesting Paolo to finish with his own inventions the little bit that remained to be completed in the arch; and taking off his toga, he clothed himself like one of the Doge's equerries, and mingled with them in the Bucintoro [the ducal barge] which sailed out to welcome the king. During the voyage he secretly painted the proposed portrait of him in crayon. This small sketch he used as the basis for the life-size portrait. Having become a friend of the treasurer of the King, Monsieur Bellagarda, he was, after many delays due to the continual visits of princes, shown into the royal quarters in order to do the retouching from life. While he was in the process of painting and the King was graciously admiring his work, a shipwright from the Arsenal daringly entered the room and presented his badly made portrait, saying that when His Majesty had dined at the Arsenal he had drawn that likeness. His temerity was squelched by a Knight who pulled it from his hands and, piercing it with his dagger, threw it into the Grand Canal nearby. This affair gave rise to the rumor that went around that Tintoretto's portrait was considered unsatisfactory.

Tintoretto also noted on that occasion that from time to

time there were presented to the King certain persons whom he lightly touched on the shoulders with his sword, to the accompaniment of other ceremonies. Pretending not to understand the significance of this, he asked Ballagarda about it. The latter told him that in this way they were created knights by His Majesty and that he too should prepare to receive that rank, since he had talked about it with the King, and the King appeared to be ready (knowing his condition) to recognize Tintoretto's merit by making him too a knight. But the artist, perhaps not wishing to subjugate himself to titles, modestly refused the honor.

He then presented the portrait to the King, who happily received it, considering it to be a marvel since, although the artist had made it almost by stealth, he portrayed him true to life and with royal dignity. The King made a gift of it to His Most Serene Highness Luigi Mocenigo, at that time the Doge of Venice, in whose house it is still.

But since up till now we have spoken of many of his principal works, discussing them to the best of our ability in chronological order, we will now deal with a large group of paintings and altarpieces scattered throughout the churches of Venice that he painted during his most vigorous period.

For the sanctuary of San Cassiano he painted two large canvases. In one we see the Savior crucified between the two thieves, with many soldiers on the mountain plain, and an executioner who had climbed a ladder so as to place the inscription on the cross. The other is of the liberation of the Holy Fathers from Limbo; and in an altarpiece is the *Resurrection* of Our Glorious Lord, with St. Cassian Bishop and St. Cecilia beside the sepulchre.

In Sta. Maria Zobenigo he painted the *Four Evangelists* on clouds writing the Scriptures on the inner face of the organ shutters, and on the outer side the *Conversion of St. Paul*. For an altar for the Duodo family he painted the Savior and St. Justina with a life-like portrait in the figure of St. Augustine.

For the sanctuary of the church of the Crociferi Fathers he painted the *Assumption* of Our Lady; and although the

Fathers had decided that Paolo Veronese should paint that picture Tintoretto was able to talk them into giving him the commission, promising them that he would paint it in the manner of Veronese, so that it would be thought to be by his hand. Nor was his promise false, since, in fact, he created in that altarpiece a blend of vigor and charm which decisively proved that he knew how to paint in any style, and could change to whatever manner was pleasing. The heads of the Apostles he painted in a most vivacious manner, with the lights in their eyes shining as if the Spirit possessed them, and he placed them in such lively and animated poses that it is useless to ask for figures that are more beautiful or movements more gracious.

In the same chapel he also painted, in competition with Schiavone, a medium-sized picture of the *Circumcision* of Our Lord, placing the table (on which the Priest and the Virgin with the Infant in her arms lean) in such a manner that below it distant figures and a glimpse of architecture are seen, thus making of it something strong and wonderful, which in fact greatly surpassed the painting of his rival. It is with good reason that this is held to be among Tintoretto's most prized works.

On a great vault in the refectory belonging to the same fathers (who, as a result of the works he had done in their chapel, were amazed by his talent) he painted the *Marriage at Cana*. Christ is at the end of the table, with the Virgin at his side and a long train of guests, and there are many servants scattered throughout the room who bring food and bread in vessels and pour water changed into wine. By the position of the table and the partitioning of the ceiling, which is divided into many spaces all drawn in perspective, the refectory is so elongated that the tables and guests seem to be doubled. The composition is reproduced in an engraving by Odoardo Fialette of Bologna, a student of Tintoretto's work.

There are two of his altarpieces in San Felice. The larger shows *St. Roch* with saints on either side and is uncommonly beautiful in its coloring. The other contains a small figure of *St. Demetrius* in armor and a portrait of the patron, who was

a member of the Ghisi family. In the Chapel of the Sacrament
are paintings of the *Last Supper* and the *Agony in the Gar-
den*. In another chapel in a half-lunette there was a picture of
Our Lady Annunciate.

In San Mosè in the Chapel of the Sacrament he painted a
picture of *Our Lord Washing the Feet of His Disciples*. In the
background servants are seen removing the tablecloths from
the tables and in the corner there are portraits of the Rector
and the Guardian of the Confraternity. There is also a small
altarpiece of the Virgin called *Our Lady of Graces*.

For the Compagnia of Nostro Signore in SS. Gervaso and
Protaso he painted another *Holy Thursday Supper* of new and
curious invention. In it Christ is seen blessing the bread,
while the Apostles are seated on humble chairs around him,
devoutly gesturing while some bring food to the table. In it,
too, are a boy bringing a plate of fruit and an old woman
spinning at the top of a stairway, both painted with great
naturalism. An engraving reproduced the composition.

And thanks to Antonio Milledonne, Secretary of the Sen-
ate, he painted for one of the altars of his chapel a *St. An-
thony Abbot* being tempted by demons in the guise of deli-
cate, elegant women. The Redeemer appears to him in a
aureole and the Saint with his eyes fixed on Him seems to be
consoled. And in this work, truly most rare, he demonstrated
how well he knew how to bring his paintings to an exquisite
finish when he judged it opportune and when the occasion
and the quality of the place required it. It also is engraved.

At the foot of the crucifix of SS. Giovanni e Paolo we see in
a small painting three scenes from the Bible, all of which
allude to the death of Christ: *Cain Killing Abel, Abraham
Sacrificing Isaac,* and the *Brazen Serpent* which Moses
erected in the desert.

In the chapter house of the same fathers there once was an
altarpiece of *St. George* killing the dragon, but the original is
now missing and only a copy is left. Some small figures by
Tintoretto remain in the pediment above the altar.

There was also in San Francesco della Vigna in the Bassi
Chapel an altarpiece of the *Lamentation over the Body of*

Christ with Nicodemus and Joseph compassionately supporting the precious body and servants with torches that illuminate the shadows of night, at which sorrowful spectacle the Virgin swoons. It was one of Tintoretto's most precious paintings but was mutilated by a sacrilegious hand. All that is left us is an angel with the crown of thorns in its hands at the top. In the sacristy of San Sebastiano there is a little painting containing a story from the life of Moses.

In Santa Maria Mater Domini he portrayed *St. Helena Finding the True Cross*. The Queen he painted in a majestic attitude with her retinue of ladies so dressed as to seem drawn from Antiquity, and arranged in graceful and noble attitudes. From it we come to understand Tintoretto's studies, and the large collection he made of things that were curious and beautiful. Here too we see how, by contact with that which has touched Christ, the sick woman at the side of the cross is cured. St. Maccario, Bishop of Jerusalem, is present, together with many people who show their amazement on seeing so great a miracle. In short, the work is replete with skilled draughtsmanship, strength, grace, and painterly artifice.

Above the door of the Church della Carità there once was seen a painting of the *Savior on the Cross,* a work so noble and delicate that it breathed divinity. At the foot of the cross there was the usual group of the weeping Marys and on the sides some bishops. But of that painting one may now say with the Angel: Surrexit not est hic. [He has arisen, he is not here.]

In S. Polo one admires another *Last Supper* where Our Lord gives communion to the Apostles, which differs from all other interpretations of that theme, for Tintoretto was not lacking in new concepts, his genius being a treasury of all the most beautiful curiosities.

Besides the paintings we have already noted, there are some fourteen altarpieces, scattered throughout other churches, that we will briefly mention. In the Incurabili there is one of *St. Ursula* who, followed by many virgins, has disembarked from the nearby boat and is carried off from the

midst of prelates, while an Angel brings her the martyr's
palm. The second is in San Daniello, wherein *St.
Catherine* resolves the doubts put to her by philosophers with such
grace and alacrity that only speech is lacking to make us
believe her alive. The third, in the Gesuati, is of the
Crucifixion with the Virgin Mother at the foot as Nicodemus
and Joseph carry out the compassionate office of taking down
the Savior from the cross. The fourth altarpiece, in San
Gioseppe, is of *St. Michael,* and it also contains the portrait
of a Venetian Senator. The fifth is in San Girolomo, with
Christ on the Cross sustained by God the Father in Heaven;
St. Adrian is at the foot of the cross, and St. Francis and St.
Anthony are on their knees. There are two paintings by Tin-
toretto in San Cosma on the Giudecca, one of which shows
Sts. Cosmas and Damian dressed in a ducal manner, with the
Virgin and other saints on clouds. The smaller one is of *Christ*
and there is also a painting of the *Agony in the Garden.* The
ninth, which is in San Marcelliano, is of that Saint in a
radiance with the Apostles Peter and Paul on either side. The
tenth, in Santa Croce, shows the *Dead Christ* supported by
an Angel and includes a portrait of the pontiff Sixtus V. The
eleventh, in San Geminiano, shows *St. Catherine* in prayer
and an angel who points out the wheel which is held by two
cherubs. The twelfth, in the little church of San Gallo in
Campo Fusolo, is of the *Redeemer* with St. Mark and the
aforementioned episcopal saint. In Santo Stefano Con-
fessore, called San Stino, is the thirteenth, in which is de-
picted the *Assumption* of the Virgin. And, finally, the last is in
the Compagnia della Giustizia; in it we see *St. Jerome* pray-
ing in a grotto covered by rough planks as he beholds a vision
of the Virgin upheld by four lovely angels. Among those altar-
pieces I have noted, this one is, I believe, worthy of much
praise for the special study and diligence Tintoretto used: in
this instance he took into account its placement only a little
above the floor. Moreover he portrayed the Saint in a manner
appropriate to his years, noting the wrinkles and creases that
occur in the skin of an old person, without at the same time
compromising the design.

And although it is sometimes observed that he cared more

about developing his ideas than creating pleasing effects with finishing touches, he nevertheless often demonstrated that he knew how to bring his works to the point where everyone could see there was no part of the painting that was not executed perfectly, and that sometimes he could even be called a painstaking miniaturist.

Let us speak now of his fresco works since that way of painting is no less worthy than working in oil. The resolute manner which is appropriate to fresco does not permit cancelling and redoing things at the painter's pleasure, for then it would be flawed, and the changes would show, much to the disgrace of the artist.

In the house of the Gussoni family on the Grand Canal Tintoretto painted copies, during his youth, of two figures taken from Michelangelo: *Dawn* and *Dusk;* and in two areas on the upper section he painted two original compositions: *Adam and Eve* and *Cain Killing Abel.* Similarly in Campo Santo Stefano on the back of a chimney he painted the figure of *St. Vitale* on horseback, sharply foreshortened, which was praised by master painters as something extraordinary. Here as a caprice Tintoretto based his design on the statue of *Bartolomeo Colleoni* in the Piazza of SS. Giovanni e Paolo, the celebrated sculpture that was the last work of the Florentine, Andrea Verocchio. On the vaults by the windows he painted some nudes which were executed with skill and in so pleasing a manner that had they been painted in oil they could not be fresher or better. In such ways he demonstrated how talented he was in comparison to others.

But among the works in fresco the most acclaim was for the one for the facade of the house of the Marcello family in San Gervaso, called San Trovaso. There he painted four fables from Ovid: *Jove and Semele; Apollo Flaying Marsyas; Aurora Taking Leave of Tithonus;* and *Cybele* crowned with towers in a chariot drawn by lions. Above these pictures he executed a long frieze filled with nude bodies of men and women so vigorously and freshly painted that they seem alive. It is moreover the most curious interweaving of figures that a painter could devise.

Thus the artist perfected his skill at handling the various

techniques through which one learns the working of his
genius and that universality that painting requires.

But let us pass on to the Ducal Palaces and speak firstly of
the paintings in the upper rooms where Tintoretto had ample
scope to demonstrate his ideas.

In the Salotto Dorato at the top of the stairs leading to the
Collegio, he painted on four medium-sized canvases various
subjects appropriate for the government of the Venetian Re-
public.

The first is of *Vulcan with the Cyclops,* who take turns
striking the iron on the anvil and attempt to bring it to a
perfect shape. This suggests the unity of the Venetian
Senators in the administration of the Republic. The various
pieces of armor seen on the ground allude to the instruments
which in military matters make for power, since arms serve
both to ornament cities and to terrify their enemies.

In the second are the *Three Graces Accompanied by Mer-
cury.* One is leaning on a die, for each of the Graces has an
attribute. The other two hold the myrtle and the rose, both
sacred to the amorous goddess, symbols of perpetual love.
They are accompanied by Mercury to show that the Graces
bestow themselves with good reason, just as favors are be-
stowed by the Senate on its deserving citizens. The Prince
who recognizes virtue and services rendered resembles God,
who leaves no good unrewarded.

The third painting shows *Mars Driven Away by Minerva*
while Peace and Abundance celebrate. By Minerva here is
meant the Republic's wisdom in keeping war far away from
the state, thus bringing happiness to its subjects and giving
rise to love for its prince.

In the fourth we see *Ariadne,* whom Bacchus found on the
shore. Venus gives her a crown of gold, declares her free, and
admits her to the company of the gods. By this is meant that
Venice, born on the sea's shore, was through heavenly grace
given an abundance not only of every earthly good but
adorned as well by the divine hand with freedom's crown,
and that her dominion is recorded in everlasting letters in
Heaven. So noble in concept and so graceful of body are

these figures that surely they breathe a divine inspiration that steals our hearts. And if ever it be true that Nature was conquered by Art here without doubt she surrendered the palm to her rival Painting. Two of those compositions are to be seen in engravings by Carracci, to whom we referred earlier.

In the middle of the ceiling Tintoretto placed the portrait of the *Doge Girolamo Priuli*, to whom Justice, accompanied by Venice, hands over the sword and scales, bestowing upon him dominion over his people, while above in the sky reading a book in a graceful pose is St. Mark, the Protector of Venice.

He then went on to paint the vault of the nearby room called the Sala degli Stucchi. In the central panel he painted *Venice* led by Jupiter to the bosom of the Adriatic, while all the gods with happy countenances assist at the foundation of the city. There is likewise in one of the tondi a figure of *Venice* holding in her hand a broken yoke and shattered chains. She is accompanied by many allegorical figures of virtues, one of whom holds a cap on a lance as a sign of liberty. At her feet stands Envy with serpents about to be overthrown. These paintings, being damaged, were restored by a painter of little skill. In the other tondo Juno bestows on Venice riches and power, giving her the peacock and thunderbolt along with other gifts borne by her assistants. Venice and Juno are surrounded by the four principal cities of the state. Two of these, Altino and Vicenza, which were ruined by time, have been restored by Signor Francesco Ruschi, a diligent and worthy painter.

In a lunette over the windows on the canal side was the *Marriage of Venice and Neptune,* making her the ruler of the sea. On the opposite side by the courtyard he painted Venice favored by the world as being unique in always keeping her empire free.

Tintoretto then went on to paint several works in the Sala del Pregadi. In a long space over the tribune, in conformity with established custom he portrayed the two doges *Pietro Lando and Marco Antonio Triviano* in adoration before the dead Savior, who is borne by angels, with the patron saints of Venice arranged on either side. In another painting in the

same room he executed the portrait of the *Doge Pietro Loredano* before the Queen of Heaven with St. Mark and other saints, and in the background we see the Piazza of San Marco drawn in fine perspective.

In the middle of the ceiling surrounded by many gods in the sky he portrayed *Venice*. On the order of Mercury, Tritons and Nerieds bring to her, as to a reigning Queen, tributes from the sea: shells, coral, pearls, and other precious things.

To complete the decorative program there remained only the paintings of the Collegio. The work was divided between Paolo Veronese and Tintoretto. The latter was assigned four large works with the portraits of the doges. Having Veronese as a competitor caused Tintoretto to put greater effort into these paintings, for rivalry sometimes serves as a spur, making the artist more attentive so as not to fall behind his competitor.

The first painting, which is near the tribune, is of the *Doge Luigi Mocenigo,* who is shown on his knees adoring the Redeemer. St. Mark is at his side. In the background are his patron saints, as well as two portraits of Senators of the Mocenigo family.

In the second he painted *Nicolò da Ponte* with Our Lady, accompanied by St. Joseph, beneath a large baldachin supported by cherubs. St. Nicholas, St. Mark, and St. Anthony are by the Doge. Tintoretto inscribed his name on that picture, considering it to be something special.

The third painting depicts *Francesco Donato* with St. Mark along with St. Francis; and he painted therein the marriage of St. Catherine Martyr to the Infant Jesus. At a little distance is Prudence holding a scroll on which is written "Vt prudentia nunquam poenitendum in magnis consilijs" [In order that Prudence might never be lacking in great deliberations]. Temperance also holds a scroll on which we read "Sic Temperantia exemplum semper sequendum Civibus dedit" [Thus temperance has always given citizens examples to follow]. These were virtues admired in that worthy prince.

Finally, over the principal door we see *Andrea Gritti* with the Virgin on a pedestal. There are many saints about her,

among them St. Marina with the palm in her hand to commemorate the conquest of Padua, which occurred on her feast day; Gritti was at that time the provveditore of the Venetian army.

It being necessary to redo the paintings of the Sala del Gran Consiglio and of the Sala dello Scrutinio because of the fire that had taken place in these rooms, Tintoretto was chosen as one of the principal painters. To him were assigned the four corners of the ceiling, on which he painted glorious events of the Venetian Republic.

In the corner toward the Quarantia he painted the *Defence of Brescia*. The city was held through the prudence of Francesco Barbaro, who during the siege bore with the greatest endurance the deprivation of food, in order to serve the citizenry. We see him portrayed on a rampart with Braida Avogadra, a generous Brescian lady, while the city was under siege by the troops of Filippo Maria Visconti, the Duke of Milan. This picture is commonly called "the sword" as there is a soldier outside the walls who brandishes a large sword against the enemy. This figure astonishes the viewer by the dramatic way it is foreshortened to adjust to the angle from which it is seen, and also by the soldier's upright posture and bold movement. In a gold inscription nearby we read:

BRESCIA WAS SAVED FROM A MOST CALAMI-
TOUS SIEGE FIRST BY THE ADVICE AND BY
THE MANIFOLD SKILL OF THE COMMANDER!

In the second corner there is a painting of the victory won by Stefano Contarino over Assareto, Captain of the aforementioned Duke. Here the marvelous outdoes itself, for Tintoretto has with such great art known how to represent the lake and the galleys all properly foreshortened, and has done so with such great skill that we are amazed at the sight of it. Many soldiers cross over to the enemy boats on gangways. On the inscription we read:

WITH THE FLEET OF MILAN SCATTERED IN
LAKE GARDA, THE LEADERS FLED, THUS

THERE IS REJOICING IN HAVING SEIZED
MORE GRAND VICTORIES AND IN HAVING
CAPTURED GREAT PRINCES.

The third one, facing S. Giorgio Maggiore, depicts the defeat inflicted on Sigismondo d'Este by Vettor Soranzo, who captured Comacchio and took as prisoners many enemy captains and cavaliers. It has the following inscription:

THE D'ESTE PRINCE IS VANQUISHED IN BATTLE AT ARGENTIA TOGETHER WITH A GROUP OF NOBLES AND A GREAT MULTITUDE OF CAPTIVES.

The fourth shows Giacopo Marcello taking Gallipoli from the Aragonese. In these scenes Tintoretto showed many sailors fighting on the spars of the ships and a group of the most fierce looking soldiers that could be imagined. The inscription briefly explains the story:

GALLIPOLI WAS CAPTURED WHILE ARAGON
FOUGHT THE COMBINED ARMIES OF ITALY.

On one of the largest wall areas on the court side he painted in a great picture the embassy that the Venetian Senate sent to the Emperor Frederick in Pavia because of the differences between him and Pope Alexander III. He painted the Emperor seated on a throne under a gold canopy at the top of a flight of stairs, the landing of which is occupied by dukes dressed in gold mantles, ermine collars, and ducal caps. The aforesaid ambassadors set forth their proposal to him. In the background are the resident ambassadors, the Papal Nuncio, and the Venetian, behind whom we see the German Guard and many people assembled in the form of an arc. In the forefront he painted a gathering of cavaliers and courtiers, so as to make the scene fuller and more decorative. It is a composition that has always highly pleased the connoisseurs.

In addition, in the Sala del Maggior Consiglio, Tintoretto was assigned the painting of an area about forty feet long in

the middle of the ceiling. There he shows a life-size portrait of
the Doge Nicolò da Ponte at the top of a stairway accom-
panied by Senators admiring the personification of Venice,
who is seated above in the sky. Accompanied by Cybele and
Thetis who symbolize her dominion over land and sea, and by
other airborne allegories, Venice, as a sign of peace, brings to
the doge a wreath of olives held in the mouth of her lion. In
the front there are several ambassadors of cities that had
voluntarily put themselves under the protection of Venice,
and they bring on large platters their keys and charters. He
also arranged on the steps secretaries of the Senate officials,
ministers, and subjects who mount the stairs with petition in
hand, as well as foot soldiers finely dressed, bearing arms and
furled flags.

But although the painting was the work of a great master,
and once in place it was pleasing to the sight, yet Tintoretto
could not escape the stings of his opponents (since virtue is
always accompanied by envy). They spread the story that he
had dashed it off as a practice work executed in a careless
manner, and he therefore feared he would encounter some
criticism. But Leonardo Corona, Antonio Aliense, and Gio.
Francesco Crivelli, young painters of much merit who were
his supporters, had hidden among the benches in order to
hear what they were saying about the picture and now and
then came forth in his defense. In this way the persecution
was overcome, and the painting, to the glory of its author, is
held in good repute by all and with the passing of the years it
has come to be revered as a precious work.

One of Tintoretto's greatest accomplishments in those
rooms (apart from a number of doges' portraits he painted for
the frieze of the cornice of the Consiglio) was his picture of
the *Recovery of Zara* in the Sala dello Scrutinio, which one
can say without exaggeration is a sun amid lesser stars. Zara
had rebelled against the dominion of Venice and called in the
army of King Ludwig of Hungary. Subsequently the Senate
sent, under the command of Marco Giustiniano, a powerful
army that laid siege to the town. Tintoretto portrayed the
action thus: In the distance we see the Venetians attacking
the city walls, which the inhabitants of Zara try to defend.

Nearby is a large machine that hurls back the assailants on
their perilously tottering ladders. The conflict between the
King's men who have come ashore and the Venetian army
takes place on the broad field. We see groups of foot soldiers
in closed ranks facing the cavalry men. Bands of archers are
hurling clouds of arrows, while others are in confused flight
on horseback. Many groups of soldiers fight fiercely. Mean-
while fresh Venetian soldiers are coming from the galleys and
are met by the Hungarians. In the foreground there is a mass
of disorganized soldiers armed with spears, pikes, halberds,
bows, and crossbows who are making a horrible massacre of
the enemy. Among them is an archer gracefully drawing his
bow. There is also a confused jumble of broken wheels, scat-
tered insignias, and severed armor; and among these ruins we
see many soldiers cruelly slaughtered by the enemy.

In short, Tintoretto displayed an instance of field warfare,
full of the most cruel happenings such as usually occur in like
circumstances. And in truth that scene, filled as it is with so
much action, could only be rendered with such force and
expression by the unequalled brush of such an artist. In this
work he surpassed everyone's expectations; being, in sum,
his own rival, his glory is finally assessed by the very works
that he painted in those rooms, which gloriously carry off the
palm.

So that we may not fail to relate what diligence demands,
let us speak of the pictures that he painted elsewhere, al-
though the bulk of the work he did is to be seen in Venice,
where he had abundant opportunity to make himself known
as a great painter. It is for those who are true connoisseurs to
gauge the value of so great a man and to do so especially from
those works which are characteristic of his genius, and by
which his merit can be understood. His genius must not be
confined to a small canvas and one cannot include everything
he painted, as sometimes he dashed off little things for the
pleasure of his friends. One cannot expect the painter to per-
form marvels in every small thing, since he often has to adapt
himself to the occasion and the time available.

There are two of his pictures in the cathedral in Lucca. One is a *Last Supper* with Christ and the Apostles, the other the *Ascension into Heaven*. Both of them are highly admired.

In his maturity he painted a *Vision of St. Augustine* appearing to some of his devotees for the Godi altar in S. Michele in Vicenza. In it are included some skilfully foreshortened nudes. In a villa for the same family he painted several things in fresco.

In Genoa in S. Francesco we see a canvas of *Christ Baptized by St. John,* and in the houses of the noblemen of that city and of other private individuals there are a number of portraits and other pictures.

In San Matteo in Bologna there are two paintings of the *Virgin Annunciate,* and in San Pietro Martire there is the *Visit of the Virgin to St. Elizabeth*.

In the Church of Sant'Afra in Brescia he painted the *Transfiguration* of Our Lord on Mount Tabor between Moses and Elias, with the disciples dazzled by the splendor. It is done in an excellent manner and is considered to be one of the most precious things of that land.

For the church of the fathers of San Domenico in Chioggia he painted the Crucifix that spoke to St. Thomas Aquinas, saying to him: "Bene scripsisti quae de me Thoma scripsisti. Quod ego retribuam tibi?" and responded: "Nil aliud quam te Domine" ["What you have written concerning me you have written well, Thomas. With what can I repay you?" "With nothing other than yourself, Oh Lord"]. For the Compagnia della Croce in Cividale in Belluno he painted two works with life-sized figures of Christ, one depicting the *Agony in the Garden* and the other *Christ before Pilate*.

In Mirano, in the territory of Padua, in the parish church he painted *St. Jerome,* nude, meditating in a forest; from that likeness radiate emotions that are divine. In Currano, also in Paduan territory, he painted a curious composition showing the *Virgin Welcomed by Elizabeth*.

In the church of San Giovanni in Murano he painted the *Savior Baptized in the Jordan*. And there at the top is God the

Father, surrounded by cherubim and infant angels and finely clad larger angels who serve at the holy office, holding His sacred robes and the white linen to dry Him.

Tintoretto also painted many things at the request of princes and lords. Of these we will mention only the most important.

For the rooms of the Emperor Rudolph II he painted four mythologies. In one there is a *Musical Concert*, with the Muses in a garden playing various instruments. In another *Jupiter Brings to Juno's Breast the Infant Bacchus*, born of Semele. The third is of *Silenus*, who comes in the dark to the bed of Hercules thinking to possess Iole; and in the fourth there is *Hercules*, adorned with female lasciviousness by the same Iole, looking at himself in a mirror.

For Philip II, King of Spain, he painted eight varied poetic themes which that great monarch much admired as works of a happy genius. Tintoretto received the commission from the King's ambassador in Venice.

For Guglielmo, Duke of Mantua, besides the friezes which we have already mentioned, he painted his portrait and that of many princes of the family. These portraits were passed on from generation to generation by those princes, who were lovers of painting.

In the gallery of the King of England there are many of Tintoretto's paintings collected at great expense by that magnaminous monarch. One is of *Our Lord Washing the Feet of His Disciples*. Two contain mythological subjects, one being the *Bath of Callisto;* both are highly celebrated.

In the gallery of the Grand Duke of Tuscany there is a magnificently painted portrait of *Jacopo Sansovino*, the worthy Florentine sculptor, holding his compass; and there is also a very beautiful picture of the *Agony in the Garden*.

Cardinal Aldobrandino had a half-length picture of *Christ Scourged,* an admirable figure.

Viscount Basil Feilding, the English Ambassador to Venice, acquired an altarpiece with many saints; another, of the *Woman Taken in Adultery*, with entire figures of less than

life-size; and a small painting of the *Dead Savior* in the arms of Our Lady; and also many singular portraits, of which that of *Aretino* seemed as if it spoke.

Monsieur Hesselino, Major-domo of the King of France, a few years ago took from Venice for his majesty two great canvases with life-size figures: one a *Nativity,* and the other a scene of *Hell,* full of nude bodies, done in Tintoretto's best manner.

The following works are still to be found with Messrs. John and Jacob Van Ussel: a painting with life-size figures of the *Nativity;* the *Portrait of an Old Beardless Man* seated, dressed in cloth made of goat's hair cunningly worked in a wave pattern; and another of a *Venetian Citizen,* also very old, with his hand on the belt of his robe; a painting of the *Virgin Mary, the Christ Child* to whom *St. Joseph* and the *Archangel Michael* (both life-size half-figures) pay homage; a *Portrait of a Man with a Small Beard;* another head; and among those, one of a little *Old Man* with a staff in his hand, whose pose conveys realistically the weight of his years; and also the *Portrait of a Man* of advanced age with a long beard wearing a robe trimmed with sable, beside a pedestal, with a book in his hand; a *Senator* with a white beard; and two women, one of whom it is said is the *Wife of Tintoretto,* holding a fan made of feathers, the other of a *Venetian Matron* dressed in red damask, painted in a singular manner.

Likewise we see in the house of Signor Nicolò Corradino a half life-size *Risen Christ,* and a richly colored *Portrait of a Youthful Student* wearing a cap and with a book under his arm.

But that is enough of an account of his works outside Venice to show how widely he was esteemed. Now let us proceed to discuss the paintings in Venice in private collections.

In his youth Tintoretto painted a frieze around the mezzanine of the house of the Miani family at the Carità. In it he represented in one part the course of human life, in the other the *Abduction of Helen,* with other compositions in the other

sections. It was painted in the manner of Bonifacio and Schiavone, with whom he had trained.

For the Signori Conti Pisani of S. Paterniano he painted in the panels of the mezzanine many fables of Ovid.

At Santo Eustachio, called San Stai, in the house of Signor Giovanni da Pesaro, Cavalier and Procurator of St. Mark's, he executed the *Four Seasons* on gilded leather. For *Spring* he represented the delights of that season, showing lovely women in gardens, varieties of flowers, birds, and hunters with dogs. For *Summer* he portrayed the work done by peasants in gathering up the crops and bringing in the harvest on carts. There are long colonnades drawn in perspective with gracious views of arbors and palaces. For *Autumn* he shows several Bacchantes intermingled with delirious youths wreathed with vine leaves and grapes dancing in a circle to the sound of cymbals. For *Winter* he portrayed several rites followed by the ancients in that season.

In the ceiling of a room he devised three mythological scenes: *Apollo, with the Muses,* playing the lyre in the center; *Jupiter and Semele;* and *Adonis Leaving Venus* as she attempts to detain him with caresses.

In the museum of Signor Cavalier Gussoni, a Senator with a good understanding of painting, we admire (besides the many excellent pictures) the figure of *St. Mark* in a graceful pose writing his gospel; a *Portrait of a Woman* dressed in the antique manner, with slashed sleeves, adorned with ornaments, colored softly; and two portraits of old men. There are also two small narrative paintings, one of *Cain Killing Abel* in a capricious act; in the distance we see God rebuking the wicked brother for his sin. The other shows *St. Paul* being converted by the voice of Christ. As he falls from his horse we see his followers scattered in fright in many directions, all represented in such graceful poses that one cannot imagine a finer composition. Among the works of Tintoretto it is indeed a gem among gems.

Signor Cavalier Lando, Senator, connoisseur, and lover of painting, has among the many excellent pictures by cele-

brated authors that adorn his rooms three portraits of his ancestors that are among the most singular of Tintoretto's work.

Among the paintings in the possession of Signor Procurator Morosini was a three-quarter length picture of *Our Lady with the Infant and Many Saints* in a group; a figure of *Vulcan* as a smith, life-size, very skilfully done; a small canvas of *St. Lawrence* on the grill, done in a very bold manner. It was painted by Tintoretto for the Bonomi altar in San Francesco della Vigna. But not understanding its high quality and believing it to be unpleasant to look at, they imprudently made an unhappy exchange for a similar subject with minute figures by Girolamo da Santa Croce; Tintoretto's drawing for the painting is still owned by his heirs.

In the house of Signor Nicolò da Ponte, a learned Senator, one admires the *Portrait of the da Ponte Doge,* which is perhaps one of the most vivid and well-executed heads that Tintoretto painted. There is also a very devout image of the *Virgin with the Christ Child* whom she caresses; and a sketch of the *Council of Trent* in which the artist represented the group of prelates gathered in session. There too one finds the Doge as the ambassador of the Venetian Republic.

The Senators Carlo and Domenico Ruzini are owners of a flourishing studio filled with many statues, antique heads, a quantity of medals, carved gems, and other curiosities. Among their many excellent paintings are several by Tintoretto: the *Miracle of the Loaves and Fishes;* the *Flight of the Virgin into Egypt;* the Effigy of the *Virgin; Apollo Crowning Poets with Laurel Wreaths;* and another in which *Apollo* appears as a shepherd near Anfriso playing the lyre as many listen and Juno gives to the people gems and gold.

In the new quarters of Signor Cavalier Luigi Mocenigo, the Senator, which are adorned with various paintings by modern artists and rich ornaments, there is a *Portrait of the Dogaressa,* the wife of Doge Luigi Mocenigo. And in the house of Signor Toma Mocenigo is the portrait of *Henry III, King of France and Poland* which we have already men-

tioned; and also a portrait of the aforesaid doge; and shown
adoring the Queen of Heaven in a long canvas are the same
doge and his wife, together with other Senators and children
of the same family, who are depicted as music-making angels
at the feet of Our Lady.

Signor Lorenzo Delfino, the Senator, has a *Portrait of a
Woman* and six paintings of Old Testament themes that are
used as overdoors. They include *Adam and Eve; Hagar and
the Angel* who points to her forehead; *Lot with His Daugh-
ters* who, after having fled the fire, give him drink; *Abraham*
held back by the Angel as he is about to sacrifice his son
Isaac; *Susanna in the Garden* with the two old men peeping
out of a pergola in the distance; and *Boaz Sending Ruth to
Gather the Alien Corn.*

Signor Ottaviano Malipiero, the Senator, and his brothers
are happy to have several very life-like portraits of their an-
cestors. Other portraits are owned by Signori Francesco and
Girolamo Contarini, in particular a very realistic image of a
woman of majestic aspect, dressed in sky-blue. Signori
Domenico and Luigi Barbarighi possess, besides the many
celebrated works by Titian and other authors which we have
described, two portraits of illustrious men of their house;
Sebastian Venier, who was later a doge, in the uniform of a
general; an oval of *Susanna* nude in the garden being aided in
her toilet by servants, as well as the two old men who are
attracted to her and admire her from a hiding place, and some
animals also are included; and there is a small capriccio of the
Muses in which Tintoretto showed his skill.

Signor Vicenzo Zeno, whose pastime of plying brushes and
colors deserves much praise, possesses a picture of the *Vir-
gin with Our Lord as an Infant* and has also from property
settlements some family portraits. He owns as well two pic-
tures about three braccia each. One is of the *Triumphant
Savior* entering into Jerusalem on a donkey; in front of Him
are some Hebrews carrying olive and palm branches, while
others as a sign of homage spread their cloaks under His feet.
The other picture, skilfully executed, is of the *Woman Taken
in Adultery,* as Our Lord points with his finger at the letters

written on the ground; we see the Scribes and Pharisees one after another leave, concealing themselves behind the columns of a colonnade that forms a splendid perspeçtive.

In the Grimani house at San Luca we see in a great canvas the *Magdalen* at the feet of the Redeemer weeping for her sins. In the Foscarini house at the Carmine there are also two canvases, a *Resurrection of Christ* and other devotional subjects. The Signori Mocenigo at the Carità have a small picture of Herod with his henchmen and his sister-in-law at table when her daughter appears bringing the head of St. John the Baptist to the wicked mother. In the house called the big house of the Cornari we see in one of the rooms, along the frieze, the departure of *Queen Caterina Cornaro* from the Isle of Cyprus; there on the beach are represented the troops of cavaliers and ladies who attend her as she boards the galley on the arm of her brother. And in the Barbo house at San Pantaleone in the paneling of a room we see a dream sequence with some goddesses in the sky and various images of the things produced in the minds of mortals in their sleep; in the surrounding area the *Four Seasons* are personified.

The Signori Navagieri at the Pietà have the portraits of *Bernardo and Andrea Navagieri*, the celebrated poets; and in the Mula house at San Vido there is a caprice of the *Muses* with Apollo in their midst playing his lyre; and in the Priuli house at Santa Maria Nuova is seen a nude life-size *St. Jerome*.

The Conti Vidmani have two excellent paintings by Tintoretto: one depicts *Christ Baptized by St. John* in the Jordan, and the other shows the *Woman Taken in Adultery* being brought by the Scribes and Pharisees into the presence of the Savior, in whose face we perceive a beauty without sin that enraptures the heart. Both paintings were executed in such a strong and bold manner that one could scarcely see on canvas more strongly modeled figures. Signor Albert Gozi has a *Last Supper*.

Most singular, however, is a long picture that we admire in the previously mentioned gallery of Signor Cavalier Gio. Reinst of full length portraits of the *Pellegrini Family*, seated

with some matrons at a garden table, with their young children also life-size coming in from the hunt with dogs and servants, carrying hares. Besides the beauty and excellence of its coloring it forms a noble and rare composition. In this same gallery, together with the paintings already described, there are also to be seen many pictures with original inventions, diverse landscapes, and other things by the most celebrated painters of our age.

Signor Nicolò Crasso, the renowned jurisconsult, has a small canvas of *Hercules* furiously casting away Silenus, who had imprudently entered his bed in the dark, thinking to enjoy Iole. She and one of her maidservants, awakened by the noise, display their very exquisite bodies, while another servant who has hurried there with an oil lamp throws light on the scene. He has, as well, the portrait of *Sebastian Venier,* skilfully done; a *Self-portrait* of Tintoretto in his youth; *The Head of St. John the Baptist* on a platter; the portrait of *Maffeo Venier,* the celebrated poet; and also one of his family.

Signor Francesco Bergoncio, a gentleman in whom the most virtuous qualities contend, possesses a very life-like *Portrait of a Man* of middle age who with one hand holds closed a coat of marten fur and in the other hand holds a handkerchief; he looks straight ahead with an expression of natural dignity. As a demonstration of his delight in and understanding of painting, he has collected not only the excellent works described in the lives of the painters of the past, but also those of the modern painters who are esteemed. Thus he has a *Susanna at the Bath* by Varotari; a half-length figure of *St. Jerome* with a skull in his hands by Spagnoletto; a *Lot with His Daughters* by Lys; another figure by Van Dyck; some noble parables by Fetti; two caprices by Bamboccio; as well as many landscapes and other paintings which we will mention in the lives of the artists which we will subsequently write.

Signor Nicolò Renieri, an excellent painter mentioned elsewhere whose merit was made known by many rare portraits and other works he painted in Venice and elsewhere, also has

a painting by that industrious hand representing an *Adoration of the Magi* with less than life-size figures, formed with the highest grace and design of the rarest invention; and one of the most curious creations of that genius, a life-size *Susanna at the Bath*. One of the old men, who is lying on the ground, hidden among some foliage (very skilfully done), watches her, and from the garden his companion looks out furtively. Renieri acquired numerous paintings which together form a singular collection. Among the other works we see a *St. Jerome* of average size meditating on the crucified Christ, a singular work by Antonio da Correggio; a portrait, in a very mannered style, by Leonardo da Vinci; *Christ Led to Mt. Calvary* by the executioners, the work of Lorenzo Lotto; a large painting by Paolo Veronese's hand of *Judith* who, having cut off the head of Holofernes, is handing it to her old servant, a work in which decorum is joined with beauty. Words cannot describe the marvelous force of the figure of Judith and her disdain for the disordered bed with the remains of the Captain. Another with the figure of *St. Jerome,* larger than life and with a lion at his side that appears to roar, is by Peter Paul Rubens; and there is a small canvas by the same Rubens of *Mars* armed with sword and shield treading on some vanquished figure as Bellona hands him the thunderbolt and Victory a wreath of laurel. There is also a life-size half-figure by Guido Reni of *Cleopatra,* who has been wounded in the breast by the serpent and, swooning with pain, seems to die little by little; and there is *Apollo Flaying Marsyas,* also life-size, by the same hand, and in his best manner.

Monsignor Melchiori, rector of Santa Fosca, admirer and protector of painters, likewise has among his famous paintings a singular portrait by that author.

Signor Paolo del Sera, a Florentine gentleman and a student of painting, acquired the portrait of a *Venetian Senator,* which is so natural that he seems alive; and Signor Paolo Rubino has in his house a painting with small figures in the manner of Schiavone.

In the dining hall of the Fondaco de' Tedeschi, Tintoretto, in competition with other painters, executed a life-size al-

legorical representation of the *Moon* seated on a gilded
chariot armed with a bow and arrows, adorned with billowing
veils and other charming draperies. With her are the Horae
who gracefully pour dew from silver urns onto the flowers.

In the rooms of the Procuratia are also seen many portraits
of procurators of St. Mark's and of the doges, done with such
fresh and vivacious colors that they seem to be alive. Stu-
dents can learn from them how to color and to arrange a
portrait in many different ways; and in the upper part of the
Procuratia there is the figure of the *Dead Christ* in a lunette.

In one of the rooms of the Avogaria he designed a long
picture of the Redeemer, surrounded by luminous radiance,
rising from the sepulchre, with three magistrates kneeling
beside Him; and two pictures of the same composition, one in
the Sala Vecchia of the Doge, the other in the room next to
the Pregadi, are both executed with the greatest delicacy.

In the Magistrato above the Great Hall he painted many
portraits of senators, some of whom are adoring the Queen of
Heaven. In one of the series he painted *St. Theodore, St.
Margaret,* and *St. Louis* in bishop's vestments, graciously
posed. In another he painted *St. Andrew* leaning on the cross
while *St. Jerome,* holding a book, speaks with him.

In the Camerlinghi he portrayed also in a long canvas the
Virgin with senators before her in reverent attitudes and ser-
vants behind bringing sacks of money. In the neighboring
spaces appear the Savior, St. Mark, and Venetia, as well as
portraits of gentlemen of the Camerlinghi. Many other paint-
ings by Tintoretto are also to be seen in the houses of Vene-
tians. In particular there are some of very beautiful color that
belong to Signore Giovanni Grimani. One of *Paolo Cornaro,*
called "the Antiquarian," in which he rests his hand on a
statue, belongs to the Signori Zaguri. Signor Jacopo Ponte,
jurisconsult, has one of a man robust in aspect and very viva-
cious; and Don Antonio dei Vescovi has the portrait of *Fran-
cheschina Corona,* the wife of Pietro de' Benedetti, Doctor,
which Tintoretto painted in competition with one by Titian of
Benedetti, and which is described elsewhere. Don Lelio Or-
sini carried to Rome the portrait of *Camilletta dall'Horto,* a

Venetian noblewoman, a work of masterful ease and grace that was formerly in the painting collection of Aliense, a renowned painter. Another painting, a portrait of a monsignor, enhances the decoration of the studio of the brothers Muselli, the Signori Christoforo, jurisconsult, and Francesco, most worthy patricians of Verona.

But those we have mentioned will suffice to show how worthy Tintoretto was in these things as well.

Finally, let us gather some of the fruits of his last years, which are not lacking in grace and beauty. In his work he followed the natural order of things, which tends to greater vehemence toward the end, and thus up until the end of his life he tirelessly painted, producing effects always corresponding to his great talent.

For the Confraternità del Rosario of Santi Giovanni e Paolo, which was given a sumptuous new building by Venetian merchants to commemorate the victory over the Turks in the year 1571 (and embellished with precious statues by Alessandro Vittoria, who was the architect, as well as by Girolamo Campagna), Tintoretto painted in the center of a great oval the *Virgin Giving the Dispensation for the Rosary to Sts. Dominic and Catherine of Siena*. Below are the major Christian princes who await that devotion, and in some of the smaller spaces he painted beautifully garbed angels who scatter flowers as a sign of joy.

On the walls he represented the *Massacre of the Turks* by the Christian army through the intercession of the Most Holy Virgin at the summit together with St. Justina, who speaks to her. In that small canvas he depicted the battle with a great number of galleys and figures of every description. Opposite the altar he painted the *Crucifixion* with Our Lady swooning at the foot, accompanied by the Marys and the Magdalen, who clings to the cross with much emotion; the bodies of many saints arise from the tombs as it says in the Scriptures, and a soldier with a very ferocious gesture breaks the legs of one of the crucified thieves.

In San Giorgio Maggiore we see four altarpieces. In one of the two larger ones, which are in the transept chapels, we see

the *Stoning of St. Stephen*, with a quantity of figures; in the second he depicted *Our Lady Assumed into Heaven*, crowned by the Eternal Father and His Son, while beneath on clouds are some of the beatified of that Order. In one of the two minor altars there is a picture of the *Savior Rising from the Sepulchre*, together with portraits of the Morosini family; in the other there are martyrs being tortured in many ways; and in the predella some of their relics are preserved.

In the Chapel of the Dead of the same convent, he painted the *Redeemer Taken Down from the Cross*. In view of the graceful mastery of form and composition in the painting, it is appropriate to honor it as a heavenly work. A little distance away on a hill the Virgin in agony is surrounded by her compassionate sisters who try by loosening her bodice to revive her. Even though Tintoretto was in his final years his mind was still active. In this work especially he showed that his brush was not lacking in ability to produce his usual marvels.

Then on the sides of the main chapel of the church itself he painted two large pictures. On one side is the *Miracle of the Manna* and on the other the *Last Supper* with Christ and the Apostles. The table is seen from a bizarre angle and lit by a lamp hanging in the middle.

By order of the Senate he painted two altarpieces for the new church of the Capuchins, of which the better one is that of the *Flagellation*. And in the Madonna delle Grazie, in the lagoon, he painted on the organ shutters the *Virgin Annunciate*, the *Resurrected Christ*, and *St. Jerome in Prayer*.

He also made many cartoons for the mosaic masters of the Church of St. Mark. The most remarkable are the two in the barrel vault of the apse, one of the *Last Supper* and the other a *Marriage at Cana* in which the figure of the steward who indicates with his hand the pitcher of water changed to wine is especially admirable.

But we are approaching the end of this great author's works, since to claim to gather together all the things he painted would be empty, and we will speak briefly of the *Paradise*, that great work that he painted in the Maggior Consiglio, with which he gloriously crowned his great career.

The Senate decided that, in addition to the paintings that

were renewed in the Sala del Consiglio, the *Paradise* Guariento had painted before the fire of which we spoke previously, should be repainted. Having decided on those innovations, the Signori debated at length the choice of the artist, since opinions were still varied after having seen many models. Finally one of the groups prevailed, and it was decided that the commission would be entrusted jointly to Paolo Veronese and Francesco Bassano. But since their styles did not harmonize, and also as Paolo died soon afterwards, before either of them had begun the work, it was necessary to have a new election. But although able painters again strove to obtain the commission, it was finally given to Tintoretto, who on his part had not failed to use every trick in order to get it. Talking at times with the senators he used to say that, being already old, he prayed to Our Lord to grant him Paradise in this life, trusting in his mercy to also obtain it in the next. His selection, however, was facilitated by the word spread by his friends that no one else was suitable for that work but Tintoretto.

For the composition he made numerous oil sketches. In one of these, which is preserved in the house of the Counts Bevilacqua in Verona, the Blessed are divided into many circles. In the end he was satisfied with the composition which we see today, although he changed some parts of it, since those who have an abundance of ideas find it difficult to be content with their first concept. He then set to work on that great canvas, thirty feet high and about seventy-four feet long, stretching it out in several parts in the Scuola Vecchia della Misericordia, which was a place suitable for so vast an enterprise. Here the good old man devoted himself to translating the model into the finished work, not sparing any effort in cancelling and redoing that which did not turn out to his taste, and availing himself of real objects in those cases where it seemed to him necessary for approximating life, such as the habits of the saints of the various religious orders and also effigies of Virgins and the Blessed. He used live models for those things that are useful to the painter, as in observing the joints of the limbs and the appearance of the muscles in bodies under stress. But the development of the

composition, the poses of the figures, the boldness of the contours, the convolutions of the garments, the clothing of the figures in a graceful manner, and finally, the brightness of the colors—all this comes from the long study and experience of a master painter.

The composition being laid out and brought to some perfection, he put it in place in the Sala del Consiglio in order to see the effect it would have. Thus with all the parts of the canvas together he set out diligently to give it the final touches. But lacking the strength for the work (being bowed down by his years and by those long hours of labor, as well as the occasional need to climb up and down the scaffolding), he had his son Domenico come and help, and Domenico finished many things from the model. According to some, however, he overdid himself in designing decorations and splendors. Nevertheless, Domenico's work was a relief for his father, for he took many tasks from him which had become lengthy and burdensome in his old age.

Considering the vastness of the composition, the countless number of figures it contains, and the admirable way the whole holds together, the mind can find no words by which the pen can express it. It is said that Tintoretto observed the order of the litanies in the placement of the saints, since we see the Virgin in the center, praying to her Son for the Venetian Republic, and the Angels, Archangels, and Blessed Spirits arranged around the throne of God. He then placed in order the Apostles, Evangelists, Martyrs, Confessors, and Virgins, filling the spaces on each side of the encircling clouds with men and women saints of the Old and New Law, and in the middle he placed a number of the Blessed, Angels dressed in graceful ways, and nude infants veiled in radiance so as to separate them from the nearby groups. Thus he composed, to the extent that we have an understanding of it, the order and union that is thought to exist in Paradise. It seems an impossibility that the human intellect could arrive at the expression of a concept so grand. Hence it is no wonder that amid the abundance of so vast a number of things the pen fails at its appointed task.

At the unveiling of such a rare example of Paradise it

seemed to everyone that heavenly beatitude had been disclosed to mortal eyes in order to give a foretaste of that happiness which is hoped for in the life to come as a reward for doing that which is good; and hence the general acclamation. By word of mouth the painting was commended by all. His friends competed in rejoicing with Tintoretto at the appearance of a marvel never again to be seen on earth. The painters themselves, overwhelmed with astonishment, praised such great mastery. The very senators congratulated him and affectionately embraced him for having brought to conclusion that great piece of work to the enormous satisfaction of the Senate and the entire city. The good old man rejoiced, exchanging happiness for the tedium of the past, his heart's true objective being the praise gained through the merit of his works, for which goal noble spirits will willingly strive.

Being then sought by the Signori who were charged with fixing his compensation, they asked him, after first commending his valor, what recompense for his work would please him, so that they might accede to his request. He responded that he desired only to rely on their favor, and they, in response to his noble manner, assigned him a generous reward. But he, so they say, did not want to accept it, being content with much less, wanting perhaps by this course to capture their affection. This produced a sense of wonderment not only among the Signori, but also among the painters themselves who had privately estimated that that work would bring a great sum.

Such were the ways Tintoretto often adopted in his negotiations, thus arousing the hatred of other painters, since it seemed to them that he damaged the reputation of art by not maintaining the requisite decorum. Whence perhaps some thought that he put so small a value on his paintings because he produced them without effort, although in truth nothing ever came from his hand that had not been fully thought through, or at least brought into its proper form. His way of working, when not well understood or when learned other than by the means he used, caused small-spirited souls who wanted to follow him but lacked his great foundation in de-

sign to end by bringing themselves to grief. Not everyone could fill his shoes. We see by the paucity of good examples how difficult it is to conquer painting and how Heaven rarely bestows similar favors save after the passage of centuries. Every connoisseur knows how small is the number of excellent painters that have flourished from the time of Zeuxis and Apelles, from which it can be deduced how Heaven favored Tintoretto with special gifts. It is also true, however, that he often abused such a great gift by painting anything that came along. Things that are reduced to the level of the domestic and the familiar greatly debase taste, just as penury increases desire in man; when there is an abundance of the greatest delicacies our nature rejects them. Nor is there any doubt that if Tintoretto had at times restrained his natural intensity, contenting himself with painting a lesser number of pictures, he would surely have gained a greater reputation with those who have little understanding of art. But not wanting anyone to ever leave his house discontented, he tried always to satisfy others and often gave his works away. Thus, burdened with many commissions, he was unable to finish everything with the same degree of application. For that reason perhaps many pictures that he exhibited were not completely finished, as he attempted by the rapidity of his work to lighten his load.

It seemed that after his labors on the *Paradise,* his fury for work slackened, and he gave himself over to the contemplation of heavenly things, thus preparing himself like a good Christian for the way to Heaven. He spent much time in pious meditation in the Church of the Madonna dell'Orto and in conversation on moral themes with those Fathers who were his intimates.

He did not completely neglect his painting, however. He executed two large pictures which were placed unfinished in Santa Maria Maggiore. One is of *St. Joachim,* who was expelled by the priest from the temple because he had no progeny; and the other was the *Marriage of the Virgin,* a masterful composition. In the same manner he painted the *Last Supper* with the Savior and his Disciples and the *Agony in the Garden* in Santa Margarita. Four medium-sized paint-

ings of the *Life of St. Catherine Martyr* were placed in the church of that name. There is in the Confraternità de' Mercantini an altarpiece of the *Birth of the Virgin* which he worked on while vacationing in his villa at Campanedo. He also painted the shutters of the organ of the Maddalena and also some other things at the request of friends, being unable to do anything less than follow his natural talent.

He also had the idea of making a number of drawings in which he proposed to leave in print some of his fantasies so they might serve as a record of his countless works, but the plan was not fulfilled since the scythe of inexorable death cuts short all human intentions.

It remains for us to speak of his habits in order to satisfy the reader's curiosity in that area as well.

This excellent man was so isolated in his thoughts that he lived far removed from all gaiety, thanks to his unceasing work and the weariness that study and diligence in art brings. Those who are immersed in speculation about painting and engaged in continual labor give up pleasure and have no experience of those things which are soft and sweet. The greater part of the time that he was not painting he remained isolated in his studio, which was situated in the most remote part of his house, and where in order to see well, he always kept the lamp lit. Here in the midst of an infinity of bas-reliefs he spent the hours meant for repose with the models he used to devise the inventions that he needed in his work. Only rarely did he allow anyone, even a friend, to enter, nor did he ever allow painters, except intimate associates, to see him at work, since the masters always kept the techniques of their excellent disciplines hidden when acclaim is the goal. These techniques the studious acquire only after lengthy observation and toil.

He had, however, a pleasing and grateful disposition. Painting does not make men eccentric, as some think, but makes them aware and adaptable to any occasion. He conversed with great affability with his friends.

He was always ready with pleasantries and charming phrases which he uttered with great grace and a noble bearing free from any trace of laughter. When he felt it appropriate he

also knew how to banter with the great and, at times, availing himself of the sharpness of his mind, his thoughts found utterance in unexpected ways.

Because his sayings and witticisms are great in number we will only note some of the more remarkable. Asked by Odoardo Fialetti, a young Bolognese newly arrived in Venice to study, what he should do in order to make progress in his work, he replied that he must draw. Fialetti again asked if he could give him further counsel, and the old man added that he must draw and again draw, rightly deeming that drawing was what gave to painting its grace and perfection.

He was visited by some Flemish youths who had come from Rome and brought with them some of their drawings of heads executed with extreme care in red pencil. When he asked them how much time they had spent on them, some said ten days and some said fifteen. "Truly," Tintoretto said, "you could not have taken less," and dipping his brush in black he made with a few strokes a figure, touching it boldly with white highlights. Then turning to them he said: "We poor Venetians do not know how to draw except this way." They were astonished at the speed with which he created, and realized the time they wasted.

He was commissioned by certain persons to paint a St. Jerome in the woods, and, as is the custom, he painted the saint nude with trees nearby. When he showed it to them they said they wanted the saint in and not outside the woods. Tintoretto realized that they wanted to offend him. "Come back," he said, "and you will find him in the forest," and with color mixed with common oil he covered him with trees. But when they did not see the figure they said, laughing: "Where is the St. Jerome?" Then he removed the color, which was not yet dry, with his fingernail and showed them the figure, thus mortifying them.

Some prelates and senators who visited him, seeing how vigorously he applied certain brush strokes while working on the *Paradise* for the Gran Consiglio, asked him the reason for doing so since Gio. Bellini, Titian, and others of the old school were so careful in their works and he on the contrary

went about his work so roughly. Without wasting any time he replied: "Those ancients didn't have, like me, so much noise and chatter to contend with." Thereupon they dared to goad him no longer.

One time, in the lodgings of Signor Jacopo Contarino where many excellent painters and other worthy persons gathered, a portrait of a woman by Tintoretto was praised, and a fine fellow turned to him and said: "That is the way one should paint." It appeared to the old man that the phrase was barbed, and on returning home he took a canvas on which was painted a head of a woman by Titian. On the other side he painted a young girl, a neighbor of his, and darkened it a bit with smoke and covered the other portrait with gouache. Taking it to the usual gathering he showed it around and everyone studied it, praising it as something singular by Titian himself. At which point Tintoretto removed the color from the first portrait with a sponge and said: "This, yes, is by the hand of Titian, but the other I painted. Now, Gentlemen, you see how much weight judgment, authority, and opinion have and how few there are who understand painting."

His brother who lived in Mantua questioned him in a letter about many things and at the end asked whether their mother, who had been ill, had died. In order to finish the task quickly Tintoretto laconically replied, "Dearest Brother, the answer to all your questions is No."

When he was painting the portrait of a prince from beyond the Alps and saw no sign of compensation, he learned from one of his courtiers how one asked for money in his language. When a good opportunity arose he asked this of the prince, who on his part entrusted his majordomo to generously reward him.

One time he was summoned by a Venetian noble to paint a certain picture in fresco in one of his gardens, and having to take the measurements of the wall he quickly stretched out his arms and measured the space. On being asked how much it was he said: "Three Tintorettos."

When he left his house, Donna Faustina, his wife, was in the habit of tying a certain small sum of money in a handker-

chief, saying that on his return he must give a minute account
of his expenditures. But he, amusing himself with gentlemen,
spent his money merrily. On being asked by his wife about his
expenditures, he gave her to understand that he had spent his
money on charity for the poor and imprisoned.

He found himself at one point in a villa where he had gone
to paint in fresco. The gentleman of the house from time to
time left him in the company of one of his beautiful ladies
while he went off to Venice on business. He was therefore
often importuned by the same lady as to what this or that
figure meant. In order to rid himself once and for all of the
annoyance he said to her: "Signora, have dinner prepared;
then, if you like, I will come this night to sleep with you and
give you five ducats." The good woman willingly accepted
the terms and, having dined, she went to bed with him. But
the poor old fellow, exhausted from the labors of the day,
could scarcely raise a feeble lance and went to sleep for the
rest of the night. Getting up early the next morning, without a
word to her he returned to his usual activity. Waking from her
sleep, the woman was astonished at not finding her lover, but
saw the agreed upon payment on the table. At this point full
of indignation and by now dressed, she quickly went to where
he was painting and began to lament about the short stay of
her amorous cavalier, and of the disdain he showed in leaving
her bed without even saying goodbye. But he, after enduring
for a short time the importunity of the woman, finally said to
her: "Be satisfied, Signora, that I did not fail in my word. But
if I were to tell the truth, I have at times enjoyed with less
expense some poor girl who was better than you are." Thus
he shamed the pretensions of the courtesan, giving her to
understand that he had paid for her services and not for her
person, as often happens also in painting.

One time a merchant, charmed by a certain figure of the
Magdalen that had been done by Tintoretto's son Domenico,
persuaded him with his entreaties to sell it to him, promising
him after much negotiating to pay thirty ducats. Since it
seemed to Tintoretto that a fat profit would be realized, he
finally sold it to him. But Domenico, on returning home and

going through his paintings and not finding it with the others, made a terrible uproar that increased when he heard that his father had sold it. Thus Tintoretto was forced, in order to have peace, to beg for the return of the picture, saying he would pay back the money or give him another by his own hand. Nevertheless he railed at Domenico for his lack of sense, complaining that he had never had such luck with one of his own pictures.

A witty fellow came to see him one time and said that, having heard how famous Tintoretto was, he wanted to be painted by him. He admonished him, however, to paint him in some extravagant pose, as he was a beast of a man. Tintoretto quickly responded: "You should go to Bassano. He will paint you in your natural state."

Asked his opinion about a painting which included men, animals, and landscapes, he said: "I like everything but the figures."

Pietro Aretino, part of the Titian faction, spoke ill of Tintoretto, who resented it, and one day on meeting him Tintoretto invited him to his house in order to paint his portrait. Aretino went and when he took his seat, Tintoretto, in a fury, drew a dagger from under his robe. Aretino, who was frightened and feared that Tintoretto was going to settle the score, started shouting: "Jacopo what are you doing?" Tintoretto answered: "Calm yourself, I just want to measure you." Beginning with his head and proceeding down to his feet, he said: "You are two and a half daggers long." Aretino, his spirits calmed, said: "Oh, you are a great looney and are always playing tricks." However, he no longer dared to slander him and became friends with him.

On his return from a certain city in Lombardy he was asked by Palma what he thought of the painters there. He replied: "Apart from Jacopo I don't know what to say, except that they are all in the dark."

He used to say that the study of painting was hard and the more one got into it the more difficulties arose and the sea always grew more vast.

He said that young students should never stray from the

path of the finest artists if they wanted to get ahead. In particular he recommended Titian and Michelangelo, the one marvelous in design, the other in color, and that nature was always the same, and that one should not alter the muscles of the figures capriciously. What would he say if he returned today to see men instructed in the painting now in vogue?

He also said that in making a judgment of a painting one ought to note whether the eye was satisfied at first glance, and whether the artist had observed the precepts of art, but that in so far as details were concerned, everyone made errors. He further said that when exhibiting works in public one should wait for many days before going to see them, since by then all the darts would have been thrown and people would have become accustomed to them.

Asked which were the most beautiful colors, he said black and white, because the one gave strength to the figures, by deepening the shadows, and the other provided the contrast. He said also that drawing from live models was only for those who were expert since for the most part human bodies lacked grace and good form.

Having seen some drawings by Luca Cambiaso of Genoa that had recently been making the rounds, he said they were enough to ruin a youth who did not possess a good foundation in art, but that a good man with experience in the profession could draw profit from them as they were full of learning.

He also said that beautiful colors were sold in the shops of the Rialto, but that design was drawn with much study and long hours from the mind's treasure store, and for that reason it was understood and practiced by few.

He also invented bizarre caprices of dress and humorous sayings for the representations of the comedies that were put on in Venice by young students for amusement. For these productions he created many curiosities that amazed the spectators and were celebrated as singular. Because of this everyone applied to him on like occasions.

In his youth he took pleasure in playing the lute and other strange instruments of his own invention, thus in every way departing from the common usage. He dressed like a gentle-

man in conformity with the custom of his time, but when he reached a mature age, with the encouragement of his wife, who held the rank of citizen of Venice, he wore the Venetian toga. Thus it was that that lady used to watch him from the window when he went out in order to observe how well he looked in that dress. But he, instead, in order to annoy her, showed little regard for it.

Among his friends and intimates were the principal Venetian nobles and learned men who lived in the Venice of his time: Daniele Barbaro, the Patriarch of Aquileia, Maffeo Veniero, Domenico Veniero, Vicenzo Riccio and Paolo Ramusio, Secretaries of the Senate, Bartolomeo Malombra, Ludovico Dolce, Aretino and many others. Nor was there a fine mind that did not make use of his skill and have his portrait painted by him. They include, among others, Gio. Francesco Ottobone, the Grand Chancellor of Venice illustrious for his writings and for his extraordinary memory, whose splendid portrait is admired in the house of Signor Marco Ottobone, the Venetian patrician, the third Grand Chancellor of that family. He attained this high rank through his merit and integrity and his house was a meeting place for all talented men.

He was honored by the visits of prelates, cardinals, and princes who from time to time turned up in Venice, desirous of seeing their faces immortalized by his sublime brush. Besides the king of France and Poland, already mentioned, he portrayed many dukes and lords of Italy and other princes and barons from beyond the Alps, and also, as we have said, all the doges of Venice who lived in his time. Their portraits are also conserved in their families' houses. The portrait of Doge Pietro Loredano is kept by Signor Gio. Francesco Loredano, the revered writer whom we have discussed elsewhere.

For the King of Arima, the King of Bugno Cingua, and the Prince of Vamusa, he also painted the portrait of Don Mansio, the nephew of the King of Ficenga; Don Michele, the nephew of Don Protaso, the King of Arima; Don Giuliano Esara and Don Martio, Japanese Barons of the Kingdom of

Fighem, ambassadors to the Holy See who also visited
Venice in 1565. On a commission from the government he
also made another painting of them as a record of their visit.
The portrait of Don Mansio was seen in the painter's own
home. Likewise the royal and princely ambassadors who re-
sided in Venice were ordinarily painted by him.

Above all things Tintoretto sought glory. All his many ef-
forts were to this end. His only thought was to open the path
to immortality, putting at naught all human happiness, valu-
ing only the delight that one derives (as the wise man says)
from doing that which is perfect. This alone is the goal of
noble spirits, since Fortune's goods are often divided among
many. But genius is a ray of grace that God is pleased to give
only to a few, so that we may recognize the special gifts of his
Divine Hand. Fortunate is the one who in this life wears the
mantle of genius.

At times he lamented that he was unable to exercise all the
facets of his talent, being impeded by excessive work and
sometimes oppressed by family burdens. Without doubt if he
had had the opportunity to paint as he wished (for his talent
was equal to any task), even greater effects would have been
seen from his fortunate brush. But the vagaries of fortune
very often deflect the mind from its best work, and spirits
battered by turbulence at times cannot function properly.
Whence it was wisely said:

> The swans long for a happy nest,
> For sweet food, for gentle words;
> One does not to Parnassus go
> With gnawing cares.

Nevertheless, from the many works that we see by his
hand one may truthfully conclude that Tintoretto was en-
dowed with those noble qualities that count most in placing a
painter at the sublime level of an art so excellent and rare.
Painting was likewise adorned by his hand with the most rare
and exquisite forms and the most unusual aspects of beauty
that were ever produced in art, for with ingenious theft he

robbed all the rarest objects of their beauty in order to embellish his figures. Thus with the death of Tintoretto painting was left both in learning and in art only with hope. Among his numerous works we mention only the following: the two great paintings in the Madonna dell'Orto; the painting of the *Miracle of the Slave* in the Confraternity of San Marco; the two of the *Trinity;* the Crociferi Fathers' altarpiece of the *Assumption;* the works in the Chapel of San Rocco; the *Crucifixion of Christ* and the paintings in the Albergo of that Confraternity; the *Capture of Zara;* and, finally, the great canvas of the *Paradise* in the Ducal Palace. Each of these paintings by its excellence would suffice to render his name ever bright and glorious.

These were the most noted and outstanding deeds of our new Apelles. To speak of his work *in extenso* would require a more ample discourse and a more effective pen. Without doubt, many of them are scattered about in various places, bringing their number toward infinity, since Tintoretto spent his time and his talent tirelessly and excellently. With his glorious efforts he showed the world the splendors of a sublime talent that in defiance of time and envy will always by mortals be revered. The works of such a great artist will serve in the future as testimonials of a supernatural genius produced by God for the marvel of the ages.

But as it is the law of nature that everyone render unto death his mortal remains, when Tintoretto reached his eighty-second year, weak and drained in strength by his great age and past labors, he lapsed into an illness of the stomach which for fifteen days kept him continuously awake. The doctors used all their art to make him sleep, thinking in that way to restore him. Nevertheless the malady advanced, since every remedy is vain when death is destined by Heaven. Then he thought of putting his affairs in order and rendering his soul into the hands of the Creator; with signs of Christian contriteness he fortified himself with the Most Holy Sacraments. Later he called his sons Domenico and Marco to his side and with many tears he said goodbye, exhorting them at the same time to preserve the honor that he had won in the

world at the cost of long labors and vigils. He asked them also to keep his body uninterred for three days, thinking that sometimes the sick, having fallen into some sort of faint, appear to be dead. Thus on the third day of Pentecost of the year 1594, with a brief sigh, his soul made the passage from earth to Heaven. The funeral procession leading to S. Maria dell'Orto, where he was buried, was followed by a throng of painters who wept at the death of their Master, by important personages, and by his loved ones whose hearts grieved at the loss of such a precious friend. He was buried in the vault of his father-in-law, Marco dei Vescovi, beneath the choir, to the accompaniment of honorable obsequies.

Thus by keeping to the laborious path of virtue through the long course of his life, Tintoretto reached glory which was his goal. Through his efforts he gathered palm and laurel, ending his days with honor and acclaim. The memory of his famous name, like the turning of the planets and like time itself, will remain immortal.

Many fine minds have mourned his death and celebrated his valor with brilliant words. But it will suffice here to note the funeral elegy inscribed over his ashes by Signor Jacopo Pignetti, the most celebrated author of our age, and by some of the writings of the most melodious poets.

VISITOR, TRAVELER, CITIZEN,
STAND AND READ THROUGH.
THE ASHES OF
JACOPO ROBUSTI
KNOWN AS
TINTORETTO
ARE BY THIS MARBLE HERE ENCLOSED.
THIS GREAT IMITATOR OF NATURE
BY HIS POWERFUL TALENT MADE SILENT POETRY
SPEAK
AND WITH DIVINE BRUSH
BROUGHT TO LIFE AND BREATH WITHIN HIS
PAINTINGS
INHABITANTS OF SUNLIGHT AND OF HEAVEN.

THESE WILL VORACIOUS TIME, ADMIRING,
GUARD.
IN THE TEMPLE OF IMMORTALITY FAME WILL
PLACE
FOR ALL ETERNITY
RECOGNITION OF HIS PAINTING AND HIS WORLD.
YOU WHO READ THIS PRAY
FOR THE WELL-BEING OF SO FINE A MAN
AND THEN, REJOICING, GO.

This man painted all things in all modes
 He himself became all sorts of painters, he was one
 for all.
No other age will produce another like him
 From this time forward he will be one for all.

Though Tintoretto did not bring fictive figures to life
 Yet he was not less than Pygmalion
Who brought to life but one.
 For from his soul to thousands he gave life
 unending.
 By M. Antonii Romiti I. C.

The mirror of Nature,
Artificer divine, magic painter,
With glorious care
To shadow you gave spirit and to color, soul;
To the dim and motionless eye,
Sparkling light and loving movement.

Ivory he made come alive
And penetrating into hidden flames of love,
He painted moist lips
In which one senses loving murmers.
He gave expression to playing and to singing,
Laughter he made joyous and lamentation wan.

To the dead he gave life
With the quickening of his lifegiving color;

It is a boundless marvel
To make with art the mortal face immortal.
And when the eyes he painted
With images of sense he senses conquered.

Night he displayed, and all about
Amid the shadows and terrors wandering spectres he
 made.
Light he gave to day,
Bright to the sky and tempests to the sea;
And to the eye disclosed
In visible form the Heavens, Angels, God.

Now bright and burning
He follows longed for loves,
With them at dawn
He blends his heavenly hues
Tints the first rays of dawn,
And in the sky a lovelier sky unfolds.

 By Sig. Cavalier Guido Casoni

Weep Adria, not alone, but with Italy and the whole
 world.
 Extinct is Tintoretto in whom God
 Joined Art together with Design and then
 Adorned him both with grace and thoughts
 profound.

He died, yes; but this fleeting form laid by,
 With pious prayers he turned toward Heaven above
 To contemplate that which his works contained
 And what his learned fertile style revealed.

That which he did on earth, that which he knew,
 Of Heaven's glory and the Beatified
 And apprehended with his mind divine:

At last those mysteries, deep and most concealed,
 With the light kindled by Eternal Love
 In the Supreme Mover now he sees revealed.

 By D. Filippo Ridolfi

A Portrait of Tintoretto

In Venice born, as a young boy I dared
 To follow in the worthy Titian's path.
But in that school my talent served but to
 Inculcate envy and to kindle rage.
I Nature conquered, Death I overcame
 With study, genius, and with daring too;
And with my brush I reached the highest plane
 Of art both in the hues and the design.

No work ere mine did truly represent
 The violence and the fury raised by Mars,
The frightful slaughter and how Death itself,
 Enraged and savage, reigns in every part,
Then into glorious tumult all is changed.
 Assaults and combats with my art I show
And from defeated and from demolished ranks
 Bring back as trophies flags and arms of war.

When in a lovely countenance I joined
 Color and line, all were enthralled, and Love,
To take in conquest still more hearts and souls,
 Made of my brush the torch and then the bow.
To pullulate with putti and with Graces
 And various delights that please the eye,
I made the ugly beautiful and made the feigned
 Appear alive within my picture's frame.

Now Muses with their soft sweet songs do pass
 The tranquil hours with me, and with them I
Draw the cartoons, and they meanwhile prepared
 Panels and canvases to music's sounds;
The amorous goddess did her robe ungird,
 Revealed her milkwhite flesh, her locks unfurled,
So that her beauty, filled with charm and joy
 Formed an eternal model for the world.

I showed how in a body filled with life
 The muscles tighten and emotions grip;

That which to earth gives nurture and abounds
 In cavernous horrors of some far-off cove,
The tempests of the sea, and salty waves
 That inundate and yet can still allure.
For in the end the subject of my brush
 Was that which God and Nature did create.

 By the Author.

The Life of
Domenico Tintoretto, Painter, Venetian Citizen, and the Son of Jacopo

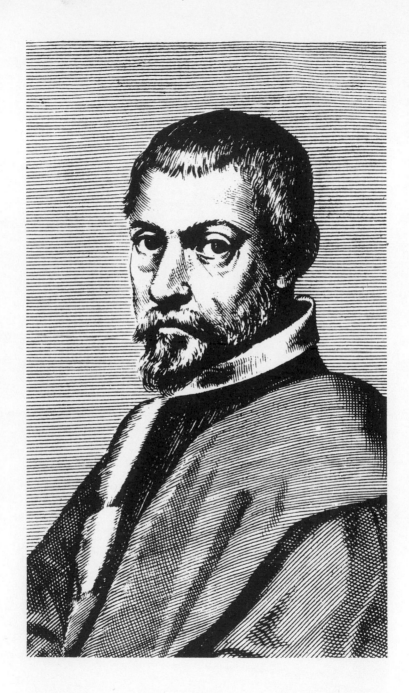

f Domenico had understood the state in which Heaven had created him, by arranging that he be born to such a fine father through whose example he could have aspired to great things by following the direct path, he would, without doubt, have left a more worthy record of his achievements. But, disdaining to continue on the true path, he strayed from his father's manner in order that the world could certify that it is more improbable for Tintorettos to be reborn than it is that there be more than one Apelles. The works that he did in his youth gave everyone grounds for admiration. An example is the picture of the *Miraculous Multiplication of the Loaves and Fishes* in San Gregorio in Venice, where the group of Christ with the Apostles is particularly fine and the figures of a poor man and an old woman are very lifelike. Another example is the *Visit of the Magi* in Santa Maria Maggiore. In the Scuola de' Mercantini he painted in the same style the *Angel Appear-*

ing to the Shepherds and the *Adoration of the Magi* before
the newborn Savior, where we admire elegant figures in both
the foreground and background. Therein he painted the Vir-
gin Mary in a very gracious action. He also devised many
singular portraits in those parts of the altar where his father
painted the *Birth of the Virgin*. In the ground floor room he
painted the altarpiece with *St. Christopher* crossing the sea
with the Child Jesus on his shoulder. Later, he painted other
pictures there, but in a different style.

Above one of the doors of the Cappella del Rosario in SS.
Giovanni e Paolo he also painted in this style the picture of
the *Holy League* in which he portrayed, as large as life, Pope
Pius V, King Philip II of Spain, and Doge Luigi Mocenigo
prostrated before the Redeemer and the Virgin Mother. In the
background there are portraits of generals Don Juan of Aus-
tria, Marcantonio Colonna, and Sebastiano Venier, together
with St. Justina, who is in the sky holding a palm; in the
distance we see the naval battle. In a corner amid foliage is
the portrait of the Guardino of the Compagnia which is so
lifelike that he almost seems to breathe.

After his father's death Domenico painted in the Sala del
Maggior Consiglio the arrival in Venice of Baldwin, Count of
Flanders, Harry, Count of St. Paul, Louis, Count of Savoy,
Bonifacio, Marchese di Monferrato, and other crusaders who
formed part of the Soria expedition against the infidels. They
are shown at the moment when the Doge, Enrico Dandolo,
mounted the pulpit of the church of San Marco to speak to
them, and the various commands within the League were
assigned. In it appeared a mixture of standard bearers, sol-
diers, and other people. He depicted the choir in fine perspec-
tive, so lifelike that it seemed real. This picture was much
praised for being a fine composition, but the painting deterio-
rated and another one of lesser beauty by a foreigner from the
north was put in its place.

Above the great window nearby Domenico then painted
the Doge himself, who, having defeated the rebellious citi-
zens of Zara, is met by youths dressed in white bearing the
keys of the city in basins, and by the clergy carrying crosses;

in the distance a group of women and girls, also dressed in white, place themselves at the mercy of the Prince, who, having punished only some of the leaders of the rebellion, benignly receives the thanks of the city.

In another space on the same level he painted the second conquest of Constantinople by the same doge and by the Holy League. He depicted the action with a great array of galleys and soldiers who climb the city walls from which the clergy with reliquaries of saints and various citizens appear to receive the doge and the princes of the League. Although they had rioted against the youth Alexius, who was subsequently executed by the tyrant Alexius Mourtzuphlos, and in many hostile ways opposed the leaders, they received pardon from them.

He also painted some celebrated altarpieces. In San Giorgio Maggiore he painted the one of *St. George Killing the Dragon;* in SS. Gervasio and Protasio, *Christ on the Cross;* in S. Eustachio, called San Stai, the *Assumption of the Virgin.* In the Scuola of San Marco at the sides of the altar he painted a series depicting the *Translation of the Body of St. Mark to Venice* and the miracles that happened during the voyage. And in a large canvas he painted an *Apparition of St. Mark* in the Ducal Church, with portraits of many members of the confraternity, dressed in crimson robes.

Similarly in S. Giovanni Elemonsinario he painted in a lunette the *Doge Marino Grimani and his Wife* (the Dogaressa) and the Polaiuoli in adoration before God the Father.

In San Jacopo di Rialto he painted *St. Anthony Tempted by Demons* in various guises and in a corner, very lifelike portraits of Silvestro Nicolini of the Three Dolphins and Giovanni dal Prete, both goldsmiths.

At this time Domenico was summoned to Ferrara by the Contestabile of Castile, the Milanese Governor. There he painted a portrait of *Queen Margarita of Austria,* whose marriage to Philip II, the King of Spain, was celebrated in Ferrara by the pontiff Clement VIII. As it turned out to be a very good likeness he received a rich gift. The Duke Vicenzo Gonzaga, who was at the ceremony, took him with him to Man-

tua. There Domenico painted him wearing a breastplate deco-
rated with very fine gold inlay, which was deemed to be a
very well-executed work, and indeed other examples of his
hand are to be seen there. It is said that while he was painting
the Duke's portrait, members of the Curia came to receive
instructions as to the sentence to be carried out against sev-
eral condemned men. Domenico pleaded for mercy for them
and it was granted. He also painted on that occasion *Duke
Gonzaga's Wife, the Duchess,* and the *Duchess Margarita,*
the widow of Duke Alfonso II of Ferrara; and for the Duke he
painted a *Magdalen* wrapped in a mantle which was copied in
a print, and other devotional works. On his departure the
Duke honored him with a gift of great value: a chain of gold
from which hung a medal bearing his portrait.

And since Domenico had acquired much fame with por-
traits in his youth he had the opportunity of making a number
of them not only of Venetians but also of princes and gentle-
men from outside Venice. Since there were a great number
we will mention only the main ones here: the *Doge Pascal
Cicogna,* whom he portrayed in his early years; the subse-
quent doges, *Marino Grimani and the Dogaressa,* his wife;
*Marc Antonio Memmo, Giovanni Bembo, Nicolò Donato,
Antonio Prioli, Francesco Contarini, Giovanni Cornaro,
Nicolò Contarino,* and *Francesco Erizzo; Prince Luigi d'Este;*
the *Count d'Aron,* the son of the aforementioned Contes-
tabile of Castile; he also painted *Ottavio Rossi,* captain of the
Genoese army, standing in a suit of armor like the knights of
old. The beauty of this portrait attracted many noblemen
from Genoa to come to Venice during the Feast of the Ascen-
sion to have their portrait painted by him. He painted numer-
ous portraits of the Spinola and Fiesca families in particular,
from which he drew much benefit.

And he also portrayed at various times many prelates,
among whom are *Monsignor Gessi,* the Apostolic Nuncio to
Venice who was later made a cardinal; and also the Cardinals
Prioli, Valiero, and *Cornaro; Agostino Gradenico,* the *Patri-
arch of Aquileia; Giovanni Emo,* the Bishop of Bergamo; and
others. Many ambassadors of sovereigns also had their por-

traits painted by Bassano since he and Domenico competed in that field and were both considered excellent. Among these were *Don Francesco di Castro; Monsieur Frenes,* the French Ambassador; *Dudley Carleton* and *Sir Henry Wotten,* Englishmen; and other resident agents of princes. The *Duke of Oxenfort,* nephew of the King of Denmark, the *Count of Arundel and his Wife the Countess, together with their Children,* and a great number of gentlemen, particularly the English and the German, also had their portraits painted.

He also portrayed a number of Venetian nobles and senators whose names it would take too long to list. These portraits are to be seen in their houses and in those of their heirs and in the offices of the Camerlinghi, the Avvogaria, and Censori. In the Procuratie there are portraits of procurators and génerals and doges which are so natural and lifelike they seem alive.

He painted portraits of *Jacopo Girardi* and *Leonardo Ottobono,* Grand Chancellors of Venice, and *Marco Crasso,* Grand Chancellor in Candia, who is dressed in ducal robes. The portrait of Crasso is in the house of Sig. Nicolò Crasso, his worthy son. He also painted the secretaries of the Senate, *Giovanni Scaramella, Francesco Maravegia, Agostino Dolce, Camillo Ziliolo, Luigi Quirino,* and *Celio Magno* who wrote of it:

> While in your colors do I truly see,
> Domenico, the image of me painted,
> I am unsure if Art has conquered Nature,
> Or if instead in double life I breathe.

> Indeed around both thoughts my thoughts revolve;
> Before my fictive self my self gives way
> Since my true self will be by death destroyed
> While in the other shall I conquer death.

> This canvas then your genius does reflect
> And must among your finest works be placed
> Winning the highest honor for your brush.

> With such acclaim you rise up to the stars,

Since, noble Painter, know I envy not
E'en Alexander for his famed Apelles.

He also painted a great number of portraits of the lawyers: *Ludovico Usper, Valerio Bardelino, Giovanni Vicenti, Michiel Marino, Tadeo and Giovanni Battista Tiraboschi, Oratio Gella, Marco Ballarino, Christoforo Ferrari, Lelio Cereda, Marino dall'Oca, Luigi and Giovanni Ferro*, the latter a most learned prelate, *Pietro Gradenico, Mario Belloni, Guido Casoni*, an illustrious poet, *Antonio Aliense*, the famous painter whom he represented seated with his glasses in his hand, dressed in slashed sarcenet that seemed like silk, *Ascanio*, called "da i Christi" [the Christ-figure-maker], an excellent ivory sculptor, *Perazzo Perazzo with his Children*, and *Carlo Ridolfi*, the writer of this biography. In short, it seemed that every worthy subject and every lady of consequence of the time wanted to be made famous by Domenico's brush. He used to embellish the portraits with lovely and magnificent friezes, bringing the image into being in a fine and easy manner. He also painted many portraits for the confraternities of the artisans of Venice who are accustomed to having themselves painted with the images of their patron saints.

But even though Domenico drew much praise and profit from painting portraits, it is to be regretted that they were given precedence over his other work, and took pride of place.

In his final years he painted other works for the churches of Venice in which we see well-ordered compositions and seemly color. In San Lorenzo he painted the altarpiece of St. Paul throttled by his executioners and Saint Ursula martyred with her companions in Santa Maria Celestia. There is also one of his canvases in San Bonaventura; two in San Daniello; several narratives relating the *Acts of the Apostles* in the church dedicated to their name, the altarpiece in the Confraternità della Misericordia with the pictures around it, and others for various churches and confraternities.

In the church of San Giorgio in Verona one still sees his

beautiful altarpiece of the *Mission of the Holy Spirit*. There are also altarpieces by him in Brescia, Feltre, and Aquilea, and in the parish church of Mestre he did the altarpiece on the high altar with the *Virgin* sheltering under her mantle some members of the confraternity.

But finally, at the age of seventy-four, Domenico was stricken with apoplexy and lost the use of his right hand. He continued to paint with his left but to little effect.

He was very creative, being filled with ideas to which he gave expression in many historical, poetical, and moral themes, having devoted some time in his youth to the study of literature. In particular he took from Ariosto the subject of the rose-like *Verginella,* dividing it into four canvases. In one she is in a garden by a hedge of roses; then, alone, she rests far from the flock and shepherds; afterwards the wind, dawn, water, and earth bow before her; and, finally, in the fourth canvas, she stands surrounded by many maidens and by youthful lovers who adorn their hair and breast with red roses. These were his favorite works.

From Lucretius and Marino he portrayed the life of man fraught with many misfortunes, sitting on a cradle with one foot on the edge of the tomb, implying (as was said in the life of Giorgione) that: "From the cradle to the grave is but a short step."

He also painted various subjects taken from Ariosto: among them *Medoro and Angelica, Olimpia,* and *Calcina.* Other stories told by that illustrious writer he painted in his early manner. They are in the Molina house at San Gregorio.

He delighted in composing verses. He took part in the entertainments of the nobles and the learned men of the city, and, like his father, was often visited by the most important and outstanding citizens.

He thought of making a gift of his own house with the studio full of the reliefs, drawings, and models that had belonged to his father, so that an academy of painters might be formed where everyone could study. But he later changed his mind because of the vexations he experienced with the painters themselves. Instead he left as heir of all the things of

his profession Sebastiano Casser, a German citizen who had been his student, and who was a good painter, and had served him for many years, it being a debt of Christian gratitude to recognize those who have given their services when needed. But this did not end Fortune's favors to Casser since, with the death of Domenico, he became the husband of Signora Ottavia Tintoretto and, at her death, was made heir of what remained of all that her valorous father and brother had acquired.

Domenico did not live much longer after that stroke. His illness continued until 1637, when he died at the age of seventy-five. He was buried near his father. And since his virtue had made him worthy of honor and praise, his loss was mourned by the whole city, which saw the glorious Tintoretto family become extinct.

The Life of
Marietta Tintoretto,
Painter, the Daughter
of Jacopo

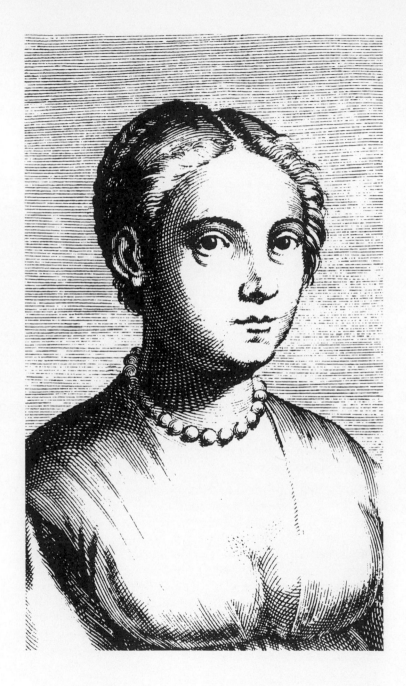

landerous tongues shoot their darts as they please. They concoct satires and invectives against the female sex, singling out as their greatest accomplishments the use of the needle, distaff, and spindle, and in painting their faces, entwining their hair with ribbons, gems, and flowers, and learning from the mirror how to be charming, how to smile, and how to be angry with their lover. These are accomplishments whose praises a thousand pens have not failed to celebrate. However, we do see pages written about the merit of Hippolyte, Camilla, Zenobia, and Tomyris, renowned in war; of Corina, Sappho, Arretta, Cornelia, Hortensia, and of Lucretia Marinella (who is now living) and others who are renowned in literature; and, even more, of the worthiness of Timarete, Irene, Marsia, and Aristarete who were celebrated in painting in ancient times; and, in modern times, of Lavinia Fontana and Irene da Spillimbergo, disciple of Titian; and this talent is illustrated in our

own day by Chiara Varotari and Giovanna Garzoni. From
these examples we clearly understand the high level that
feminine perspicacity attains when women acquire learning in
the various disciplines. However, it is a fact that that un-
happy sex, because of being reared within the confines of the
home and kept from the exercise of the various disciplines,
becomes soft, and has little aptitude for noble pursuits.
Nevertheless, in spite of man the female sex triumphs, armed
as it is by the beauty that serves it well.

Marietta Tintoretto, then, lived in Venice, the daughter of
the famous Tintoretto and the dearest delight of his soul. He
trained her in design and color, whence later she painted such
works that men were amazed by her lively talent. Being small
of stature she dressed like a boy. Her father took her with him
wherever he went and everyone thought she was a lad. He
also had Giulio Zacchino, a Neapolitan considered excellent
in music in those days, instruct her in singing and playing.

Marietta's special gift, however, was knowing how to paint
portraits well. One of *Marco dei Vescovi,* with a long beard,
is still preserved in the houses of the Tintoretto family, along
with that of his son, Pietro. She also portrayed many noble
Venetian men and women who took pleasure in meeting and
associating with her because she was full of noble traits and
entertained them with music and song.

She made a portrait of *Jacopo Strada,* the antiquarian of
the Emperor Maximilian, who presented it to his majesty as a
rare work, whence the emperor, charmed by her valor, made
enquires about her of her father. Philip II, the king of Spain,
and Archduke Ferdinand also asked him about her. How-
ever, Tintoretto was satisfied to see her married to Mario
Augusta, a jeweler, so that she might always be nearby,
rather than be deprived of her, even though she might be
favored by princes, as he loved her tenderly.

She also painted other works of her own invention and still
others that she derived from her father. She painted many
portraits of goldsmiths who were friends of her husband,
some of which we have seen. But with the dying out of these
families many of them have been lost.

Marietta had a brilliant mind like her father. She played the harpsichord delicately and sang very well. She united in herself many virtuous qualities that singly are seldom found in other women. But in 1590, in the flower of her age when she was thirty years old, envious death cut short her life, depriving the world of such a noble ornament. Her father wept bitterly, taking it as the loss of a part of his own inner being. He mourned her with unceasing tears for a long time and had her buried in Santa Maria dell'Orto in the tomb of his father-in-law. Her husband, too, in his very heart and soul was no less in perpetual mourning.

This excellent lady will serve in the future as a model of womanly virtue, making known to the world that gems, gold, and precious clothing are not the true female adornments, but rather those virtues that shine in the soul and remain eternal after life.

INDEX